Notes from Millennium Beach

organized & edited
by Bob Young

2

Notes from Millennium Beach

organized & edited
by Bob Young

Preface by David Brown, President
Art Center College of Design

NEW
PARADIGM
BOOKS

Pasadena, California

Serendipity's other name is Joanne Stevens. The graphic look of this book is entirely her doing. Was it just luck that I took an office across the hall from Joanne Stevens Design in a funky South Pasadena walk-up? Not likely! While collaborating on a book, "Walking Wisdom for Women,"[1] with my ink drawings and Joanne's design, we found ourselves laughing a lot, often joined by Barry Wetmore (page 33) and David Tillinghast (page 47), down-the-hall neighbors. Joanne's enthusiasm for this project kept me going at times when giving up would have been quite defensible (and sane). She has taught design at Art Center and currently oversees design for a Los Angeles financial firm. A great, big thank you, Joanne! You are an amazing artist, great companion, big-hearted helper, and, I'm glad to say, friend.

[1] by Elaine Ward, published by the North American Racewalking Foundation, Pasadena, California

Organized and edited by Bob Young

Art direction and cover design: Joanne Stevens

Cover painting: Bob Young

Production photography: Ken McKnight

Library of Congress Cataloging in Publication Data

Notes from Millennium Beach / organized & edited by Bob Young
preface by David Brown.
 p. cm.
ISBN 0-932727-11-5
1. American literature—20th century. 2. Millennialism—Literary
collections. 3. Twentieth century—Literary collections
I. Young, Bob, 1935 -
PS536.2.N65 1999
081--dc21 98-31264
 CIP

Printed and bound in Canada by Friesen Printers

Contents

Contents /continued

Preface

Where two worlds meet is the richest ground-meadow and woods; sea and-stream; ocean and shore. There is life the most dense, the most intricately adapted; the most at-risk.

Evolution happens at these edges and intersections. And though we can't see the process, we are the result.

Now our imaginary counting system brings us to an edge and an intersection (at least in the West). Our species' and culture's un-fightable urge to quantify and control given life and gravity by a counting system—our little symbols imposed on earth's unknowable time.

In our minds, at least, two worlds are now about to meet as this Millenium becomes the next. And even though it's all in our minds, it will be the richest ground—and the most at risk.

What a wonderful journal Bob Young, his many collaborators, and the artists who speak in their eloquent visual languages have given us to take on the journey. But let's keep in mind that this edge is only in our minds, and that for most of the rest of life, and the earth who bore it, shapes it, and sustains it, it will be just another day, just another year.

— David Brown, President
Art Center College of Design
Pasadena, California

Introduction

...[I am] looking to each individual with the eager hope of finding there something of the dignity of life, the humor, the humanity, the kindness, something of the order that will rescue the race and the nation.

— Robert Henri, American artist (1865-1929), on
a plaque near his painting "Laughing Child" in
the Whitney Museum of Art, New York

One night early in 1995 I awoke with fragments of an essay whirling around in my sleep-fogged head. They were the gist, the nucleus of a terribly urgent "message to the next Millennium."

Weird? Yes! My right brain seemed to be urging me to get these thoughts down on paper. Weirder still, it semed important that I share them with—who, exactly?—inhabitants of Millennium III.

Having once worked as a journalist, I was forever writing little polished gems of columns (and trenchant commentary) in my head. Most lasted until the next stoplight. But this essay idea kept pestering me. Pretty soon I enlisted the help of friends, neighbors, former teachers, work colleagues and acquaintances. "Imagine," I asked all these people (nearly 300), "that you could float a message in a bottle to be discovered on some lonesome beach and read in the Third Millennium with great excitement." The response astounded me. Nearly 40 said they would write essays. Another 40 said they would contribute art work. Some said they would do both.

Many did. And the result is in your hands.

These are "Bob's Folks," one individual American's circle of friends and impact-makers. This book is bursting with their hopes and thoughts and, yes, fears about the coming 1,000 years on planet Earth—and, with their wonderful drawings and etchings and paintings and digital images.

In the top floor gallery of the Whitney Museum of Art, I linger by a portrait of a "Laughing Child." The artist's fast, sure brush strokes against a dark background are perfect. Spellbinding. The artist is Robert Henri—one of a group of New York iconoclasts who later became known as the "Ashcan School," and were encouraged by Gloria Vanderbilt Whitney. Henri's words at the top of the page strike a perfect opening tone for "Notes From Millennium Beach." I hope you will share my own joy and amazement that an artist working in the early 20th Century should see in the faces of ordinary people "something of the order that will rescue the race and the nation."

"Rescue the race"! What a sweeping, daring and hopeful concept. Something of that "order" observed by Henri may be found, I think, in the essays and the art in this book.

Back on the porch, your feet sandy and your shoulders warmed by the early morning sun, you uncork those bottles that you have discovered out on the beach at the high-tide line. You pour a fresh cup of coffee, lean back in your Adirondack chair, and smooth out the yellowed paper. Hmmm... it's... a message. Let's see, a message from... the last... Millennium. How *about* that...

— *Bob Young*

Dedication

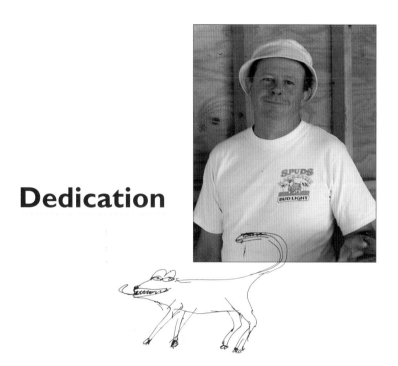

This book captured the imagination of my Art Center teacher, encourager, mentor and friend, the late Dwight Harmon (1947 - 1996). It is dedicated with love and gratitude to a man who "loosened me up" and gave me courage to take risks in my own art work. Thanks, Dwight, and a big juicy beef bone for Enzo.

Complete notes on Dwight's legendary "media experimentation" course may be viewed on the Internet, along with examples of his own artwork. Here is the location:

http://www.primalarts.com/harmony/

John Keith Nolan
Lakeville, Connecticut
Attorney, restorer of 19th C houses, funny guy

Ready, set... unwind!

It is all so auspicious: 1,000 years. Not the turn of a century, but the turn of the Millennium, a daunting concept as well as a word with four pairs of letters in it. Where I come from, they call it the "millenimum. If, like me, you are a little intimidated by New Year's Eves, which have all the problems of the big Saturday night of the year (What shall I wear? Whom shall I go with? Whom (or what) shall I kiss?), confronting the millenimum eve is intimidating.

For that august New Year's, I want to be with a quiet, laid-back, down-to-earth crowd, not too many speeches, no pointy hats, no whooping when the ball finally drops.

I may well have found that crowd on a trip to Egypt 15 years ago. After visiting the astonishing tombs in the Valley of the Kings and the great pyramid at Ghiza, my future ex-wife and I visited the museum in Cairo. We were forewarned that, unlike most Western museums, the Cairo lacked money and was disorganized. Being Egyptian, it had a zillion artifacts but many were crammed into attics and storerooms.

A little lost, I opened a door and entered a large, poorly lit room. When my eyes adjusted I realized it was filled with a hundred or so mummies laid out in rows of open caskets. Of course, they were in their wrappings, but their facial expressions were clear enough. Many had their mouths open at different degrees, as if they had abruptly stopped a conversation when I opened the door. I walked around and took a good look. The caskets were labeled. Some were not-so-famous pharoahs, some appeared to be princesses (although, trust me, I did not look under the sheets), but most were unknown mummies, at least to me.

It was astonishing that these people had lived between 3600 and 2000 B.C., yet here they lay in quiet dignity, their heads cocked back as if looking beyond this life and time, far into the past and future, with those open mouths, as if having so much to tell.

What better crowd could you be with for the big Millennium Eve? Softspoken but certainly with much to tell, here were folks who surely would like to unwind. So when the big Millenimum Eve arrives, I will prefer to be with that crowd in Cairo, sharing their toasts to five or six millennemas, although I am sure they would dismiss this mortal obsession with the third Christian Millennium.

Why, they would ask, was there no press on this at all in 2000 B.C., or in 1000 or Zero B.C.? In 1000 A.D., why was the media more concerned with the new thatched-roof technology and the invincibility of the Saxons? What, they would ask, is the big

Where Keith comes from is Joplin, Missouri. Our friendship was born in a drab Physics 101 lab at Dartmouth, as Keith and I howled over the absurdity of the experiments. We roomed together two years, competed (sort of) for a comely brunette's affections when we were in Boston (I in the Navy, he in law school), and have lobbed fairly funny letters at each other for nearly four decades. At least, funny to us! Single now, Keith practices law in the Berkshires, where he has restored an 1810 home.

deal with another millenimum? These millennemas, they would say, come and go.

See you in Cairo, at the museum, 11:59 p.m., December 31, 1999. You bring wine, something special, full-bodied, mature. I'll bring some fresh-laundered winding sheets and a ripe Nile Valley brie.

The illustration is by Charles Bloomer. I met Charlie in an "arts lab" at the Art Center College of Design—and we found ourselves choking back laughter at the pretentious prattle of our "Fine Arts" instructor. Bonds like that don't break! Son of a distinguished surgeon, Charlie was headed for a sawbones career when he did a 180 and studied illustration. Sad for medicine (he knows where your funny bone is located). Joyful for the many who have seen his imaginative, humorous illustrations in magazines. Currently, he creates digital images of boggling sophistication as an art director with Shiny Entertainment, a Laguna Beach, California, developer of entertainment software.

Terrell Dougan
Salt Lake City, Utah
Newspaper columnist, mother, water aerobics advocate

Raspberries

Eleven years ago my husband and I built a new home. We had, with the help of a well-known architect, designed every possible feature we wanted: an ironing board that folded out; two built-in ovens and a huge cooking island; a heated driveway for minimum snow shoveling. We were on our way to perfection.

The day we moved in, we finally realized our ovens were built so low to the floor you had to kneel to get things in and out. The fold-out ironing board in the laundry room hit the washing machine and couldn't be unfolded all the way. The heated driveway couldn't keep up with the snowstorm and no one could get to us. The final blow came a few days later in the kitchen, when the painter, who was not yet finished (he left sometime the next year) said, "Lady, you know your tiles with fruit on 'em?"

"Yes," I said, looking at the cute individual tiles, each with a different fruit, displayed at random among my bumpy white tiles. They were the one thing I liked about the whole house. "Well," he pointed, "them razzberries is upside down."

It put me over the edge. It was my turning point. I sat down on the kitchen floor and started to laugh. It had finally hit me. The only way to get through this life is to give up perfection.

It took us six months and enormous patience to imagine we would ever be comfortable in this home with so many things wrong. As the years have come and gone, I have coped with an ugly, standing ironing board, a driveway we've had to ski down sometimes, ovens that lie ridiculously close to the floor, and one tile that's upside down.

On this night near the close of this year, I have taken the time to stroll through our house, the one we thought was impossible. I fondle the ironing board for the baby clothes and party dresses I ironed on it; I laugh when I remember my garbage cans dragging me down the icy driveway. I can smell the lovely turkeys we've cooked near the floor.

My granddaughter now sits on the kitchen counter and helps me cook. She traces my fruit tiles with her little fingers. She hasn't noticed the raspberry tile on the wall yet. When she does, I'll tell her the story of "them razzberries" that put me over the edge.

And I will tell her, as I will tell you, that when your "razzberries is upside down" and you can't fix it—laugh, live with it and in time a little miracle will take place.

A friend who does tiles was sitting in my kitchen the other day and said, "You know, I could change that tile for you for almost nothing."

I shook my head. "Not on your life." If you live long enough, it's the imperfections you'll treasure most.

Terrell and my late wife, Gretchen, studied art history together at Stanford. She was "Giotto" evermore. My children and I have stayed in Paul and Terrell's low-oven'd, steep driveway'd house without ever finding an upside down tile. She's been a humor columnist for Salt Lake's Deseret News... nightclub singer... actress... motivational speaker... fitness instructor... and assitant to Utah's Governor. She is a mother, grandmother, wife, and freelance writer.

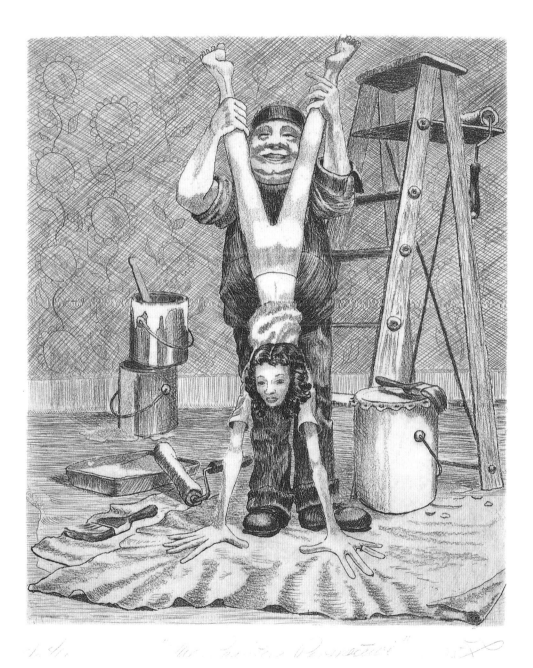

This etching is by Jim Lorigan who was my teacher of printmaking at Art Center. One reason we hit it off was that we had both served on small Navy ships called destroyers—Jim as a sonarman, I as a line officer. His Watermark Printmaking Workshop in Buena Park, California, publishes fine art editions of the highest quality. On his studio's walls, also, are some of the best paintings I've ever seen of the sea—and portraits of very mysterious (and smart) jackrabbits, snakes and other denizens of the hills behind a suburban tract. The humor and "storytelling" appeal to me very much.

Bob Gicker
1920–1997
San Francisco's warmest-hearted banker, family man, loyal friend

Strength to your arm!

Earlier in this Millennium, Ralph Waldo Emerson said, "Things are in the saddle and ride mankind."

Technology at the time of the industrial revolution was expected to free humanity from all kinds of bondage in their lives, but in fact those bondages were replaced by others and that process has replicated itself in all modern conditions ever since.

It is not important what you of the future choose as a way of life or a value system for survival. The freedom of choice is what matters! All else is bondage.

Land is scarce, water is almost gone and the air is polluted and still population will grow by billions unless you choose to slow it down. You must be free to choose to protect the environment, to reduce over-population of your planet, to develop scientific advances such as genetic engineering and the kinds of technology that will elminate poverty and hunger in your world.

But, first of all, so that "things" will not be riding you, your goal should be to find a direct access to God or to discover eternal truth.

Then, armed with the power of love, you will be able to live by principles that make all humankind free of mental, physical, economic and spiritual bondage.

It was Elie Wiesel who said, "The greatest source of evil and danger to the world is indifference. The opposite of love is not hate, but indifference."

The choices must be yours to make; so be alert to those forces which in insidious ways attempt to deny you those ultimate means of survival.

Strength to your arm!

Bob died in 1997, at his Santa Rosa, California home where he tended beautiful bonsai trees and was final-drafting a novel set in a bank. That Bob found time to write this essay a year earlier was so typical: Weren't we friends? Indeed we were. Bob's 43-year career with Wells Fargo Bank in San Francisco was truly "gutsy." By choice, this Banker's Banker had long served as his bank's one-person "ambassador" to the African American community, a tough-minded, marshmallow-hearted guy with a terrific Can Do attitude that earned wide respect. I had a counterpart job at Security Pacific Bank, and Bob was my role model and mentor. He is survived by his wife Rose Mary, three children and one grandchild.

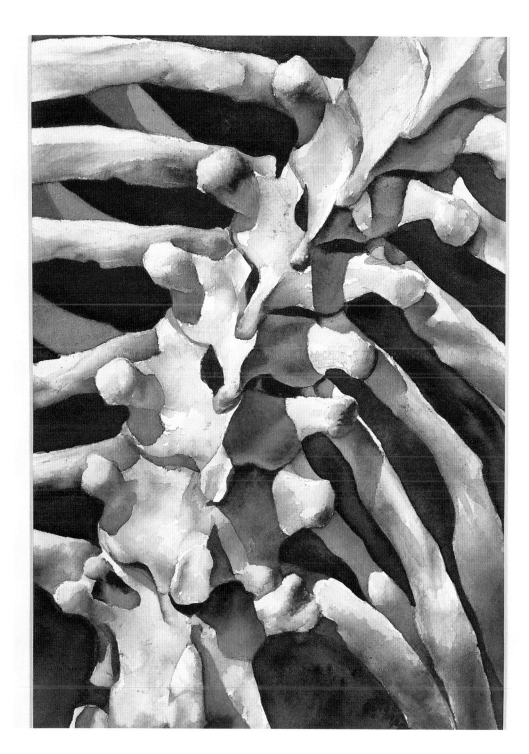

One of the privileges of going to art school is having phenomenally talented friends. All who drew or painted with John Clapp at Art Center realized that a superstar would soon be launched. Not letting us down, John already has a fine reputation for painting stunning covers for juvenile books and has created illustrations for several children's books. His clients include Harcourt Brace, Houghton Mifflin Co., and Viking/Penguin. Even better, he is a keenly intelligent, wonderfully friendly guy who hopes to go from college teaching (San Jose State, the Academy of Art in San Francisco) to heading an illustration program. *He will, he will!*

Deborah Bond
Iowa Falls, Iowa
Farm wife, mother, artist and photographer

Roots and wings...

Is there a brand new baby in your house? You can form a lasting bond with this child and make a better world too: try reading aloud.

Reading to children opens countless doors for minds which enter the world receptive to information on any subject you choose. Pick a science book this morning: read about rocks, dirt and water. Later today, recite the words from Mother Goose Nursery Rhymes. Your baby will love the rhythms and sounds. Tonight, select a soothing, comforting bedtime story.

Your baby doesn't have to be talking, walking or throwing a ball to be ready for books. Just sit the tiny infant on your comfortable lap. Wrap your arms around her, or him. You've got the book in your hands, so she can see the illustrations. It's a wonderful, comforting time to be spent together, working on the future and making a better world.

The days pass while you discover so many rewards gained from reading to your child. Time spent in this way has brought you close and allowed you to slow life's pace for a while. Your baby's even turning the pages herself!

In a few months you have a very mobile, active little person in your house. What's that he's doing? Bringing you his favorite book! He wants you to read right now! Maybe you're busy, but you're addicted to books too, so you shift gears, sit down together in that big comfy chair and dive in. There you discover animals, children and adults engaged in activities ranging from the amazing or comical to the everyday routines living creatures maintain.

After a year of daily reading, you can't live without it and neither can your child. You're on your way toward a lifetime's exposure to all the best things of life, found in the million pages you'll read together over the next 18 years. Find the classics in your library. Don't neglect the great literature of earlier days. If you've created a reader with a wide interest range and tolerance for any writing style, your grade schooler will listen to Mark Twain's "Tom Sawyer," the Arthurian legends or the poetry and humor of A.A. Milne. Experiment with the Uncle Remus stories, or Edward Lear's "Book of Nonsense" for some good belly laughs.

A few children will surprise you by teaching themselves to read before entering school. But this should not be your goal. Better to let the joys of reading simply transport you through a web of subjects: the oceans and life within, constellations and planetary composition, Native American history and culture, Earth's geography and ethnic populations. Read about relationships between friends and bonds formed with grandparents. Discover important heroes and "sheroes." Study ancient history in volumes about the pyramids. Get ready for dinosaurs! No topic will bore your little bookworm if you start reading in the early months and make your selections spontaneously.

That's the much-read-to Eddie (a teenager today) with Deb in 1986. She and husband Bob, now a banker, once farmed a real Iowa farm, in Eagle City. Their house in Iowa Falls, Deb assures me, has a furnace, not to mention dishwasher, electric garage door opener and airconditioning—items the Eagle City farmhouse lacked. Yet another graduate of Art Center in Pasadena, Deb is a professional photographer and graphic designer. Her mother, Miriam Langdon, a.k.a. "Moose," wrote the essay on page 28 titled, "Why the world wags." Her sister Molly's husband, Ed Ethridge, submitted "The Call," on page 32.

16

If every child of the new millennium arrived on the first day of kindergarten with 2,000 hours of listening to books read by family members, schools could begin educating our children and not managing their behavior. Our quality of life might improve and goals of world peace and opportunity for all finally be achieved. If it's hard for you to imagine changing the world, consider the opportunity to enjoy your child-rearing experience 100 percent more. You'll form a wonderful bond with your child and create a lifelong learner. It's guaranteed: there are no regrets when you spend time reading out loud to your children.

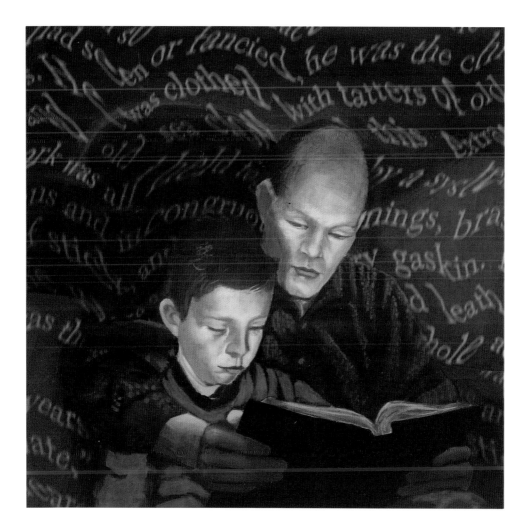

illustration

Painting portraits of families and children is Franny Harvey's goal. She will have her B.F.A. degree by the turn of the Millennium, earned from Art Center the hard way—while working part-time as a medical researcher with a team of M.D.'s at Los Angeles' County-USC Medical Center. Franny earned her R.N. after graduating from Georgetown University in Washington, D.C. Her license plates honor a frisky white dog, Honey, who follows Franny most places other than black diamond runs at Mammoth. Her way of combating deadline stress is to climb some serious hills around Pasadena on a Trek mountain bike.

Stacey Warde
Los Osos, California
Editor and writer, martial artist, helper, giver, good dad

After-shave (long after)

I was three when I made my first memorable encounter with anger and fear. My father, 23, had just put his fist through the wall next to the mirror in our bathroom, where he had been shaving.

I had been admiring him until his arm, like the bolt action of a high-powered rifle, cocked itself tightly beside his washboard stomach and sprung suddenly and smoothly into the wall before him.

I slipped quietly away, stifling my natural curiosity, not asking him what was wrong. Was he going to hurt my mom? Would I be next? Should I be scared?

My father's anger stands as a clear milestone in my development as a male child: If you can't find something—in this case, Old Spice cologne—or, if you can't have your own way, then you can lose your temper, lash out and destroy something or someone.

Better yet, I learned that when a father abandons his family—as mine did one year later and as my mother's father did when she was four—he doesn't have to worry about getting angry and hurting anyone.

I guess my father was under a lot of pressure, trying to support a young wife who bore his first child at 17 and his second child at 20.

Maybe the boss at the construction site jumped on his case about getting to work on time. Maybe the threat of Communism, daily pushing its way into the American psyche in 1961, was on his mind. Or maybe he just had a lousy day at the beach. I'll never know what caused him to vent in such a violent way.

My father died of a brain tumor at 45.

Just when I began thinking of tracking him down to ask him where the hell he'd been for the last 20 years, he died. He left this world much the same way he left his family—without warning or fanfare. He just simply left, which seemed fine with my mother.

When she related the news of his death, she may as well have been commenting on the weather.

"Oh, by the way," my mother said as I cut several slices out of an apple for a mid-morning snack, "Jim died."

"Who?" I asked, dropping my knife and feeling stunned, like a defeated boxer who never knew what hit him.

"Jim," she repeated, "your father."

I can imagine my father trying to concentrate the mix of guilt and anger in his head—the way men do when they furrow their brows and try not to feel anything—until

Into our life fell this friendly, wise, multi-talented guy named Stacey. We'd heard he was looking for a place to live through friends in our church, St. Benedict's. We'd been thinking of finding someone to live in the studio, look after our dogs & plants when we're traveling and provide a "presence" at our place. Synchronicity! Stacey likes our dogs. They like him a whole lot too. He uses my painting studio as an office where he writes, edits and produces the newspaper for the Episcopal Diocese of El Camino Real. Best of all: his lovely daughter, Anna, loves her dad, who's a patient, thoughtful parent.

t began to explode, giving birth to an alien growth that would put him out of his misery less than two weeks after his first blackout.

What was he thinking? Did he think about me? Or did he try to push me out of his head? Surely, if I could talk to him now I'd tell him what a bastard he was for leaving me. I might cock my fist back and let it fly into the wall. Then, maybe, I'd hug him and tell him I understand how he must have felt. But do I?

Lately, as I approach 40, I've been thinking: How much do I have in common with this man of whom my most powerful recollection is his anger? I'm careful to note any growths on my head and watch for signs of blacking out. I've done my best to be a better father to my nine-year-old daughter who has lived with her single mom since she was very young.

I could argue that I haven't abandoned her, even though we have not lived under the same roof for more than eight years. At least we visit one another. At least she knows who I am and that I'm available. My rationalizing sounds trite. I feel guilty and angry—guilty for not being a better father, angry for having been abandoned by mine.

I understand a man's desire to throw a temper tantrum. It feels quite natural at times. But I hope men in the millennia to come will not forget their children nor let their anger, frustration and fear drive them away from themselves and their families.

19

illustration

The illustration by Anna Warde, age nine, was drawn while her father, Stacey, excused himself to rest from a long and difficult week. She cheerfully agreed, took out her oil pastels, placed herself beside him and began to draw the tree and its inhabitants outside the bedroom window. When her dad awoke, she gave him this decidedly upbeat picture along with a hug. Anna loves to ride horses, speak Spanish with her friends from Mexico and says she wants to be a doctor when she grows up.

The photo at left was taken by a friend, Jueli, when Anna was seven. "Rough-Housing" is the name of the game.

Mark Neuman
Lewisburg, Pennsylvania
College professor, scholar of Victorian Britain, traveler, Dad

When roses sing!

Years ago, before post-modernism and Howard Stern, I wandered across the stories of the occultist Arthur Machen. This cheerfully demented Welshman lived and wrote early in our century, during and after the Decadence which you may remember was that happy time of peacock plumes and lillies and Swinburne and, in France, J.K. Huysmans.

But as I say, Machen was a Welshman, and that brings its own special freight. He was obsessed with Roman traces round and about the magic localities of Caerleon and Gwent, with altars to Pan nestled in woods on the borders of dangerous lands, with simple farm girls giving questionable birth to olive-skinned, almond-eyed get of puzzling paternity. In sum, he sought the fairies, but when he found them they were not nice to know. His fairies were not Pucks but demons, and if they got you they would take your soul to hell with them.

To find my own tiny message for the 21st Century, I went back to the mad Machen. It has to do with "the problem of evil." Of course we are droolingly fixated on evil here at our own *fin de siècle* (a good Decadent term, that). We slobber over horrors that would surely seem to come from the Depths... all those Bosnias and Rwandas, famines and ghastly diseases, wife and/or baby butchers... that irresistible litany of pain that compels us either to listen and feel and maybe even act in some small inadequate way or shut down and get off on MTV. And when we look forward across the scarred horizon to the next century, like British Tommies awaiting the whistle to go over the top at the Somme, we see nothing in view but more of the same. War, famine, disease: the Reverend Thomas Malthus's lighthearted trio, here to entertain us as far as we can peer into the future. And we name it Evil because it is, truly, so very awful.

But Machen has a different take on the matter of evil, and he has a special definition of it we just might find comfort in. He says, to begin with, even something close to evil is hard to achieve. It's easier to be a saint than a sinner. And bona fide, genuine evil is not our human pain, nor must it be ugly in its looks. It is a different stratum altogether. Here's his definition: Evil is... WHEN ROSES SING!

What do you suppose he means by this? For one thing, he is telling us that we have never met genuine evil because it is simply bigger and stranger than human affairs. If this is so, the corollary must be that all those mortal afflictions we suffer as Earth people are only the price we pay for living at all. We are born, we eat, we work, we make love, we sicken and die. Our difficulties are not Evil, only the cost of our ticket to the funhouse.

What then is Machen's Evil exactly? It is the fundamental disordering of the order of things, the Cuisinarting of Creation, the violation of spiritual propriety. It is unalloyed COSMIC WRONG. Only our self-absorption confuses the terrible personal and social... inconveniences... of war and famine and disease with Machen's Evil.

Mark and I were classmates in grades 6 through 9 at Polytechnic School in Pasadena. One smart kid! Funny, too. At Pomona College, he majored in "history and off-campus living." After earning his Ph.D. at U.C. Berkeley, Mark joined the history faculty at Bucknell, a very fine liberal arts university in Pennsylvania. He never left. It is safe to say that I have never heard a rose sing—but I like Professor Mark's message and his piquant language—Tabasco Sauce for our collection.

Here at last is where my small message of hope for the Millennium comes in. If my daft Welshman is right, and our agonies are only the stuff of life and not titanic evil, then they're "inherent" only because they have been around for a very long time. Like us, they're just life-size. So too are their antidotes and remedies, and generations of the new century, living and dying far below the threshold of evil, stand a good chance of overcoming those pains and… inconveniences… wrestling them down, knocking them about if not completely out.

But next time you're in Wales, stick to the main roads.

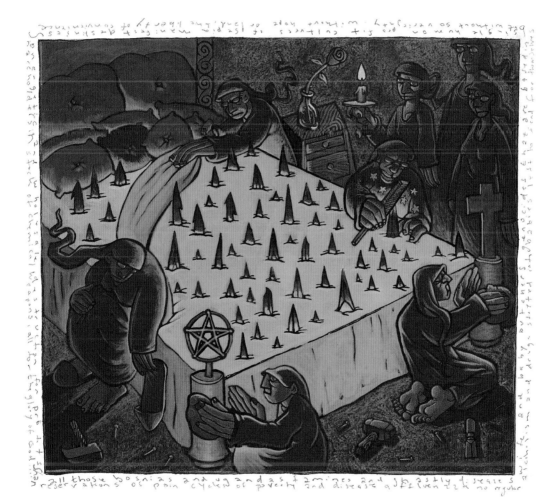

The illustration is by a wise, strapping, handsome young artist named Shan Wells. He wore a pigtail and peasant p.j.'s, so I—in my Righteous Middle Age Man outfits (and attitudes)—kind of steered clear. Until I saw Shan's hilarious drawings up on the crit rail a few weeks into my first term at Art Center. Total melt-down! We've become buddies through his marriage to the achingly lovely Regina and the birth of their two children. Having earned a Master's of Fine Art in New Zealand under a master sculptor, Shan has begin teaching college-level studio art and art history in Durango, Colorado. Keep your eye on this guy. He can *think* as well as sculpt and paint and draw!

Diem Kieu Pham
Ann Arbor, Michigan
Intrepid photographer, Girl Scout activist, ball of fire

Finding the goodness

I'm turning 30 as calendars on this planet I'm riding are turning 2,000. My life, as with everybody else's, has been and will be but a speck of dust in the history of this Earth and yet we have been led to believe that we, that is I, can make a difference.

A difference in… what? Is it so important in the greater scheme of things? Perhaps not, but in my own delusions of grandeur I would like to believe so. I believe it isn't so important that I—we—influence and change the history of the world but, rather, it is more important that we influence and change ourselves and our immediate society. The one in which we share on a daily basis, whether that be our families, friends, or the communities in which we live.

If I can begin to see myself for who I am and find the goodness which lies within me, if I can stay true to this goodness, then perhaps I can begin to change myself. If my actions reflect the good which is within me, then maybe, just *maybe*, I can help you see the goodness within yourself. If you can see this, then perhaps you would be willing to show others the goodness which lies within them. If I can see the goodness in you, then you will never be my enemy.

Change begins with each individual. I believe that the world can and should be a better place—a place where people live together with compassion, tolerance and under-standing of each other's different beliefs, traditions and cultures. There is no excuse for the suffering of others. I believe that I, that is we, can change the world. It is not so important that we leave our mark on this Earth, for we are but a drop of water in an ocean called Time. The only matter of importance is that the world changes *in the aggregate* for all of humanity's betterment. If we act collectively, then we are all empowered equally, no one person greater or better than any other. If our common societies, our common humanity can live together in peace and harmony today, we will not have to concern ourselves with the future of our children, for there will be nothing to concern ourselves with.

The ideas I write here are neither new nor profound. I write them to simply share my thoughts and personal revelations. I write them with the hope that maybe I can touch one other life. If I could make just one wish for the next Millennium it would be a wish for hope. We have nothing without hope.

story

At Art Center I met this human comet nicknamed "Zim," a photography/fine art major of uncommon zest and courage. When Saigon fell in 1975, Zim was five. Her family eventually settled in Southern California and Zim got involved in Girl Scouting, attending national and international conferences. Since graduating in 1992 she has traveled widely (and wisely) in places like Bangladesh, Mexico and Thailand, always bringing back amazing documentary images made with a beat-up old Nikon. Zim freelances from Ann Arbor, Michigan. Prediction: one day, Zim will win awards as a photojour-nalist for the Washington Post, *or* Newsweek, *or…*

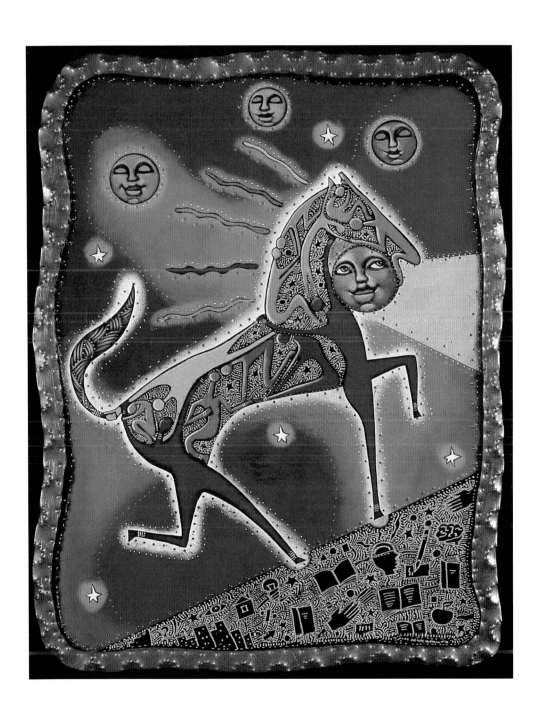

The painting is by Joel Nakamura, my instructor in advertising illustration at Art Center. "It's folk art with a bizarre urban edge," said one reviewer of Joel's work. His "very tribal, highly symbolic" paintings deal with "sex, death, bones, dogs, seafood and cellular phones." For such a big-name guy, whose work is hugely admired in the business (lead articles in *Communication Arts* and *Step by Step Graphics* have featured Joel's vibrant, wild-side work), he has a heart to match. Pushing me hard to reach beyond visual clichés, Joel provided badly needed encouragement as well as mold-breaking art intelligence. Joel and his wife Kathleen and daughter Paloma (age three, in 2000) and dogs Crispo and Picard live in Santa Fe, New Mexico.

Phil O'Brien
Whittier, California
College librarian, gentle and thoughtful Human Being

Reference point

Humankind has invented time and its divisions for itself in an effort to regulate the universe for its own needs. Centuries and millennia are aspects of that attempt and special attributes are attached to each. This book is evidence of the deep implanting into the human psyche of those artificial attributes. When midnight on Sunday, December 31, 1999, rolls around, the world will pause a bit longer in the wonder of leaving the Twentieth Century and entering into the next. It will be strange for many, many days and weeks to begin the date with a "20." All our lives we have been in the grip of "19." The closest we can come to a similar change is to go back to the year 1000, which was a more deeply religious era. Many in the world then waited for the Millennium and the anti-Christ to manifest themselves. Perhaps we will do the same, but less openly, and perhaps with less religious fervor.

This book is intended to give you, our children, grandchildren, and the few unrelated strangers who may skim through a copy in an antiquarian bookstore in the decades to follow, a sense of why we are bothering. It is to satisfy a ritual of humanity'sneed to find meaning. Nothing will change in the turning of the universe because of our entering the 21st Century—no new dawn for humanity will have opened. The world's problems will remain and perhaps increase.

The changes that matter are so slow that it takes thousands of years for them to become part of the fiber of our thinking, to become second nature and a matter of reaction when events challenge them. One example is this present generation's struggle to accept the computer. Even though I am using a word processor (will that term remain, I wonder?) and the microchip is invading every aspect of life in the industrialized world, none of us really knows where it will all lead. For coming generations will it have become much like the telephone — a part of the everyday landscape?

A second example is our desire for a life without violence and the threat of violence. If asked today about violence, the common response would be that we are worse off than even so short a time as 20 years ago. But glacial as it is, there has been progress. In the time of Julius Caesar the Romans would have, without a twinge of conscience, killed every man, woman and child in a region because of a raid on one of their outposts. Even the victims would have felt there was nothing wrong with that. It was part of life. In today's world, deeply embedded in the mind of humanity, is an abhorrence of killing and, while we all fail in perfection, progress has been made in this area of a profound sort, even though violence is still with us. There is reaction against it, shared by most of the peoples of the world.

Phil's devotion to his own school, Whittier College, is long, wide and deep. Currently serving as the college librarian, his published bibliographies of authors Jessamyn West and T. E. Lawrence have won scholarly praise. His track performance and his coaching are celebrated in the college Hall of Fame. I met Phil when I was hired to produce a capital campaign booklet for Whittier College in the mid-80s. His friendly, wise, humorous views (and his diplomatic aplomb) made a fine impression. Plus… the guy owns a '74 Volkswagen van and "a grandfather version of a Nimrod tent trailer—almost older than time!" Cool!

If you look back at all to the time before your own, know that some of us were fairly good, and some were very evil, but most were a mixture of virtue and vice whether we wore silk or rags. Taking us all-in-all we failed in some degree—but none was without some virtue, and all were equal in that we lived in time. It is humans who have created time's measurement. It is a framework of our own creation which both gives us a reference point for living and traps us at the same time.

The photograph is by Diem Kieu Pham—"Zim" to her many Art Center friends. This amazing bundle of creative energy came to America as a child when her family fled a besieged Saigon. More about "Zim" may be found with her essay, "Finding the Goodness," on page 34.

Kathy Ross

Sterling, Virginia
Artist, classmate at Art Center, mother, grandmother, calming Influence

Crawling, walking, bridging...

For some reason I am taken with the idea of "process."

This is probably because I feel that I'm good at process. Years of sewing garments from start to finish and the process of raising seven children have most certainly helped me to sort out steps in a certain activity—that is: what should be done first and the sequences thereafter. It also helps in problem-solving like anticipating and figuring out what the next step is likely to be and whether it will work.

Thinking about this essay—about what wisdom I'd like to pass on to others in the next Millennium—I suddenly realized that everything in life is a process. We learn to crawl before we walk; we learn to roll over before we crawl; and before that we learned to strengthen our muscles to allow us to use our bodies. Well, you get the point.

Process is a very important part of art. Jackson Pollack realized this and created works that demonstrate that "the process is the art." To paint on canvas it has to be stretched, primed, gessoed before the actual work is begun. To paint a wall you have to assemble the tools first; you may need to mask-off edges to avoid marring other surfaces, stir the paint, etc. It leads me to believe that preparation is a key ingredient for any process.

Hopefully, this has established the fact that everything is a process. But what happens when certain steps in the process are not used?

Say, for instance, you've just painted a wall, but an unsightly smudge has appeared. An essential part of the paint process is waiting for the paint to dry. But what happens if the wall is washed before the paint is entirely dry? It doesn't take much imagination to envision the consequences in the form of a gobbledygook mess! Further, sanding it prematurely would compound the problem.

So I've learned that each step in a process is extremely important and, if each step is done well, it operates to ensure a more successful outcome.

Where is this all leading? Well, I began to relate the idea of process to the development of a relationship, especially that of finding one's soulmate, or marriage mate.

So I began to see a river separating two individuals who want to be together but are on opposite shores. How can they get together? What are their options? They can begin to build a bridge from their own side eventually to meet in the middle. That way they could cross to each other's side at will, or bridge the gap, so to speak. Think of the shore as a symbol of your past, where you have come from and of which you can't escape because it is an integral part of you.

Perhaps they could take a ferry boat across to reach the other person. However, the ferry must continue to depart and embark at scheduled times. Also there is the cost of the fees to contend with. (This could represent the people who try to maintain long-dis-

story

Kathy and I were "silver streakers"—among the oldest students at Art Center. Starting art school in her 50s, with seven children and "4.5" grandchildren, Kathy uncomplainingly drove three hours each way to attend classes! Following her husband Bob's work in aerospace, Kathy moved to Virginia where, in juried art shows, she quietly wins praise and prizes for her paintings of real people... and angels. Serious interests: grandchildren and gardening. "Frivolous" ones include travel and renovating a cottage in the pines.

tance relationships.)

Or they may be in a hurry, decide "Phooey with this noise!" and instantly jump into the water to meet. Now they have to struggle to stay afloat. If the river becomes treacherous, they may be so concerned with their own safety in order to "keep their heads above water" that it becomes difficult to try to connect with one another. I can see them now, struggling with all their might through the rapids and churning waters, forever in danger and with nothing to cling to.

That's the scenario as I see it. The most difficult process, that of building a bridge to meet, is certainly the most lengthy one but would have the most chance of success. Because it keeps in touch with both shores, the individuals would not lose their sense of self. Of course, the bridge scenario can be broken down into finer images. For instance what if one person is not focused, is hesitant, unsure, or whatever, and is slow in beginning their side of the bridge? The other person, meanwhile, is overextending herself and building at a faster pace. So maybe one side is half finished while the other is only a quarter finished. This could in turn weaken their resolve to connect, and result in an unfinished bridge.

The point: process in a relationship needs to begin with a good foundation, with a firm resolve from both parties.

There is no easy process for forming a good relationship. It takes honest hard work. To plunge into the unknown in turbulent waters is almost certain disaster.

27

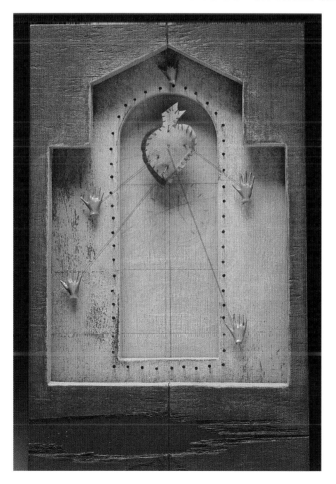

Maria Rendon Harmon is a native of Mexico whose 3D work appears frequently in *Business Week*, *Town & Country*, *Worth* and the *Los Angeles Times*. Her illustrations for "Touching the Distance" (Harcourt Brace & Co., New York, 1998), a children's book of Native American riddle poems by Brian Swann, are sensitive, clever and simply wonderful. "Pita" was in many of my Art Center classes. Following her graduation, she married the late Dwight Harmon (Dedication, page 9). Gentle, kind and wise, Pita has countless friends. Her art is awesome!

Miriam "Moose" Langdon
Des Moines, Iowa
Mother, grandmother, sage village elder

'Why the world wags'

The coming Millennium: Who among us can expect it to endure? Many of us expect that people will destroy the Earth. This belief, beyond hope, helps us to live one day at a time.

Enter human nature which has been and will be with us forever. Steinbeck in Cannery Row defines it thusly:

> "It has always seemed strange to me," said Doc, "the things we admire in men—kindness and generosity, openness, honesty, understanding and feeling are the concomitants of failure in our system. And those traits we detest—sharpness, greed, acquisitiveness, meanness, egotism, and self interest are the traits of success and while we admire the quality of the first we love the produce of the second…"

I want to say to Doc: "You are speaking of stereotypes. You are leaving out the individual goodness we see everywhere around us."

And yet… and yet…

One way to live happily in the face of human nature is to find heroes for oneself, to return to in person or in print for comfort or reassurance—as I often do with writings by the late Lewis Thomas, M.D., who said: "I listen to music for the quieting of my mind."

Another way is to take the advice Merlin gives the despondent young King Arthur in T. H. White's *The Once and Future King*: "The best thing for being sad," he said, "is to learn something. Learn why the world wags and what wags it. That is the only thing which the mind can never exhaust…

"Learning," he continued, "is the thing for you."

Finally, human nature finds it almost impossible to let others live their own lives—it thinks in terms of certainties. Thus I urge you to try to live into your 80s. They are totally unlike your 70s when all you said and did was scrutinized sharply.

When you become 80 you are automatically seen as needing help. Your curiosity, which hopefully you have retained, will be seen as eccentric if not downright dangerous.

If you drop something, perfect strangers will hurry to pick it up. And so on. This can be nice. However, you are thus deprived of exercise which can lead, inevitably, to a wheel chair. Be careful not to fall into this trap.

Our human natures need a lot of discipline!

Mother of one of our essayists, Deb Bond, and mother-in-law of another, Ed Ethridge, "Moose" and her husband, Herschel, live happily in a condo high above Des Moines, Iowa. She is a grandmother many times over. Laughter comes easily and naturally to this attractive and very "plugged-in" octogenarian. Why "Moose"? Daughter Deb made up names for all family members as a little girl who adored animals—and "Moose" just sort of stuck.

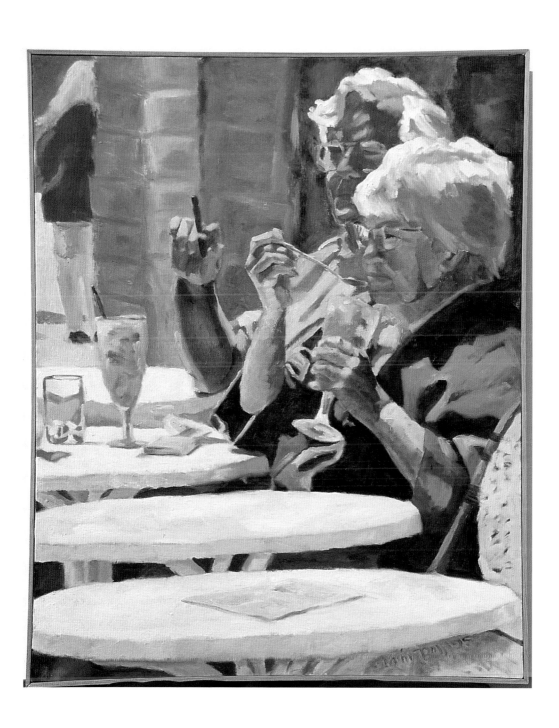

29

You met Kathy Ross on pages 26 and 27—as author of the essay titled "Crawling, walking, bridging." Her art career has grown quietly, steadily and brilliantly since 1992 when I knew her at Art Center. Her paintings of angels and ordinary people are winning ribbons in juried exhibits. When a group of us students took lunch-hour Power Walks, we learned about Kathy's determination to become an artist despite all the obstacles of being a dedicated wife, mother and grandmother. She commuted six hours to spend eight hours drawing, painting, and studying color theory—and rarely missed a class. She has taught me a great deal about "spirit" and "determination."

Kara Dixon
Fine athlete, lovely young person, spirited & cheerful "girl next door"

Skinny is...

What's in store for teens? Cigarette ads say it is okay to smoke while posting a surgeon general's warning saying that it could kill you! Some ads tell you how to dress or the way to put on your make-up.

How dangerous are these ads? Nowadays, most of these ads are harmless, but the endless repetition does have an influence. Teens really don't have to do anything they don't want to do, do they? One example of something that could harm someone is becoming anorexic or bulimic because of the sudden desire to be thin. Models wearing a size 4 or 6 aren't a realistic example for every girl.

As a growing teen, I think these ads have a bigger impact on us because of a teen's desire to be accepted. As time goes on, models and other idols to a lot of people will have become an unattainable goal. Back in the early 1900s it was okay to be a little overweight, and skinny was probably 50 pounds more than today.

Some teens say they are not influenced by ads, but you know they have been influenced by someone—a peer or a parent. These others had to have been influenced in some way and, in the end, that person was influenced by his/her idol.

In 1998, teen suicide has grown. Often, a teen's role model commits suicide to escape the pressures of stardom—we think. Tragically, teens think committing suicide will solve what in most cases turns out to be a temporary problem.

So how will teens react to the media in the next Millennium? I hope teens will learn to accept their bodies and, even more, themselves. Committing suicide is no way to escape usually temporary problems.

So, for those of you who don't enjoy yourself, remember that you are beautiful both inside and out. You are the one who knows yourself best, so don't try to push your body and mind to an unreachable goal.

Our neighbors Tom and Diane Dixon have two sprightly girls, Kara and Krista. This essay, by Kara, 15, has been illustrated by her younger sister, Krista, 12. Kara is a dynamite softball pitcher whose team, the Central California Cruisers, went to the Nationals AFA Girls' Fastpitch tourney in Barrington, Illinois in 1997, coming in 9th out of 49 teams.

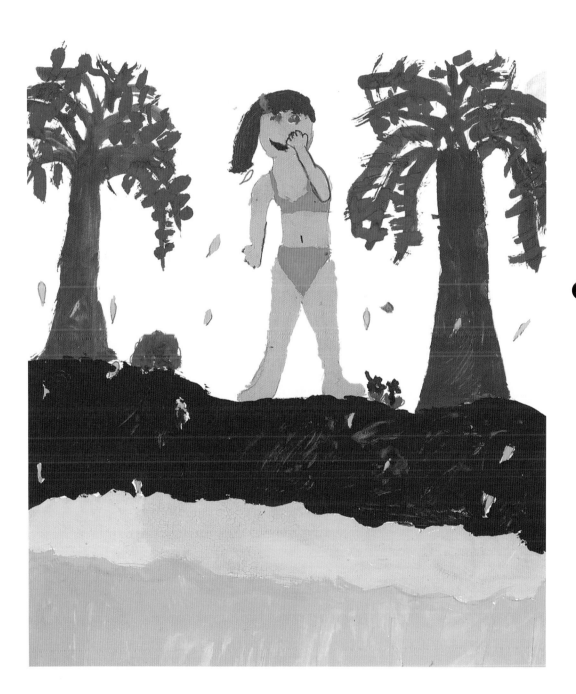

Krista Dixon illustrated her sister Kara's essay with this colorful painting in tempera — her vision of a teenage girl who is either skinny or not skinny, depending on which part of the century and which Millennium the viewer inhabits. These super girls live next door to us in Los Osos. Krista likes to draw. She likes cats, and the family dog, Molly, and two goats, Chester and Meiko. Most of all, Krista likes horses — and has been practicing formal ring work, jumping, dressage. She doesn't mind getting up extra-early to keep Jon Henry well-groomed.

Edgar Ethridge
Winnetka, Illinois
Marketing whiz, clothes horse, whimsical humorist, devoted parent

The Call

A disc of light first seen this night
By Molly and me alone and hovering
Above the withered, weary summer trees
Like swarming bees hums insistently,
 Be kind, be kind, be kind.

Or is it more like beacon, beacon, beacon?
"Did it just move?" she asks.
Beacon roughly rhymes with seekin',
So I poetize, "Maybe there's something it's seekin."
 Be kind, be kind, be kind.

No time for rhymes: it's moving.
"Come on, let's watch it from the lake!"
The lake breeze is up, soothing
And smoothing the fevers summer creates.
 Be kind, be kind, be kind.

"Bring a cup," she says, "Maybe
We can lure a flying saucer to the beach."
Just might work, I thought: sounds crazy.
Lake-ish little waves lap the beach lazily:
 Be kind, be kind, be kind.

Alliterating in the presence of an alien light,
I realize what it's all about:
Fun, gentle fun. The moon in flight;
Us in our pajamas;
We want to call to you, to shout:
 Be kind, be kind, be kind.

Ed and Molly Ethridge often walk the few blocks from their house to gaze at Lake Michigan. In 1987 they were married. Both had gone to Stanford way back when— and became engaged. Later, going separate ways, they were married, then widowed (Molly) and divorced (Ed). Their flame was rekindled when friends invited them along to Hawaii—neither knowing that the other was invited. Whoosh! Ed loves to laugh and so does Molly, which is good for them and for me.

illustration

Most of the illustrations Barry Wetmore creates are wonderfully humorous. His advertising clients have included airlines, motorcycle makers, well-known household products and large city transit systems. Barry draws directly onto a card-table sized digital tablet situated off to the right of his powerful Macintosh computer. Because his eyes stay fixed on the screen, not his hands, a visitor gets the eerie impression that the colorful images are blossoming inside the computer. Office neighbors for a joyous year, Barry and I laughed a lot and genuinely enjoyed one another's work.

Nancy West

Shaker Heights, Ohio

Educator, camping enthusiast, mother of three, grandmother

Peace within

As I watch my granddaughter sleep and think of her future, the greatest gift I could ask for her, and for all of our children's children, is peace. Not just peace for Bosnians and Israelis, but peace within each one of us and peace within families.

A song I remember from my childhood at Aloha Camp in Vermont sums it up very simply and well:

> *Peace I ask of thee oh mountains*
> *Peace, peace, peace.*
> *When I learn to live serenely*
> *Cares will cease.*
> *From the hills I gather courage,*
> *Visions of the day to be,*
> *Strength to lead and faith to follow,*
> *All are given unto me.*
> *Peace, I ask of thee oh mountains*
> *Peace, peace, peace.*

A person with inner peace accepts his or her weaknesses and strengths and radiates a sense of harmony and an ability to give and receive love. Each of us needs inner peace in order to find contentment, happiness and self-actualization. A person at peace is self-confident, willing to take risks and comfortable with others. As we approach a new Millennium, I hope that each of us will make inner peace a priority—whether we find that peace through prayer, meditation, communion with nature, good literature or exhilarating exercise.

A family whose members are at peace within themselves can be honest with each other and find comfort within the family unit. As an educator I see far too much discord, or lack of peace, between parents and between parents and children. Children from homes where "love is lived" are eager to learn, open to new ideas and positive about all that life has to offer. We personally may not be able to make peace abroad, but each of us is able to make a difference in a small way with those we touch daily. What better way to spread peace than to live it with those who will be the mainstay of the 21st Century—our young people?

Nancy directs the Hathaway Brown Middle School in Shaker Heights, a suburb of Cleveland. Her daughter, Ashley, and my daughter, Jody, bonded for life as tentmates at the Aloha Hive Camp on Lake Fairlee in Vermont, age about 11. Having herself formed lasting friendships and savored Vermont summers at the same camps, Nancy has served as a board member of the Aloha Foundation. A graduate of Smith College, she earned her M.A. in curriculum for gifted students at Cleveland State University.

story

Melinda Howell is my special "Art Buddy." Words such as bright, zesty, creative, humorous—and brave—cannot adequately describe this *summa cum laude* graduate in fine art photography from Arizona State. Melinda has a terrific eye for... rubble! Indeed, we have collaborated on two gallery exhibits (Melinda's photos & my paintings) titled "Rust, rubble & regeneration." Some of her work (corroded metal & found objects) may be viewed on the Internet, at **www.rustart.com**. Melinda has studied with master welders, sculptors, and enthusiastic rubble-rousers at the Anderson Ranch Art Center in Snowmass, Colorado. She lives in South Pasadena and balances her art by working as a legal secretary with a Los Angeles law firm.

Andy Greensfelder
Novelist and enlightened ex-attorney, husband, parent, brother
San Luis Obispo, California

Coming alive

My brother, Ted, recently died from pancreatic cancer. Several days before he died, Ted lost the use of his neck muscles so that when he sat up, his least painful position, his head fell forward. Ted's wife, Linda, his two children, Tim and Abby, and my wife, Jeanie, and I took turns standing behind him and holding up his head, our hands against his forehead.

Ted and I came from a family where touching meant shaking hands and brushing cheeks. I told him how good it felt to hold his head, to touch each other. I related a memory, from our twenties, when we had thrown our arms around each other after the home football team had come from behind to win in the last minute. We had been stunned by our impulsive intimacy. Now holding Ted's head brought tears to my eyes. Unable to speak, Ted squeezed my hand.

While Ted and his family would have embraced the cure for pancreatic cancer the next Millennium will undoubtedly supply, I am grateful for the resourceful life Ted led after receiving his diagnosis. At the Smith Farm Center for the Healing Arts, Ted discovered new emotional, spiritual and creative resources. He wrote: "While cancer is a serious illness, my cancer is not the terminal event. Rather, cancer has become my 'sentence to life'."

In his last year, Ted traded his law practice for photography. He shot pictures of birds of South Florida, which Sandra Berler exhibited in her Chevy Chase, Maryland, gallery. One of these pictures accompanies this essay. Yet, I think Ted would say that his greatest achievement was his emotional connection with family and friends, the intimacy felt when together we accepted his illness and coming death, the times when we touched each other.

The next Millennium will deliver an avalanche of technology. We'll live longer in better health. Still we'll search for how to nourish our spirits.

Ted's lesson, delivered in the squeeze of his hand and the feel of his head, is that while we cannot create the perfect world, we already can have the best that life will ever offer: the ability to reach out to others, to express and reveal ourselves, to listen to and accept each other—in short, to touch one another. Tenderness allows us to accept and embrace that which is human and beyond perfection.

story

The brothers Ted (left) and Andy Greensfelder, in a 1995 photo. Both attorneys, Ted practiced in Washington, D.C. and Andy in St. Louis, Missouri. My new friendship with Andy barely beat the end-of-Millennium deadline. Taking part in a "spiritual journeys group" we discovered that we're both outlanders new to California's Central Coast, and Bliss-followers who have made mid-life career changes. Seriously pursuing the writer's solitary life, Andy is finishing his third novel. It's about an attorney whose pro bono work for Legal Aid brings him into conflict with his law colleagues.

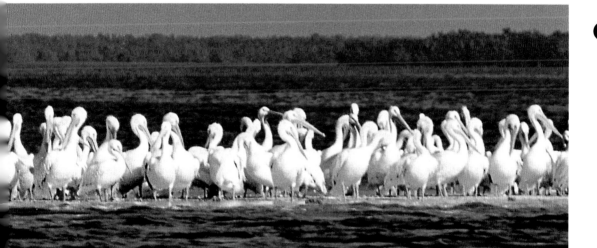

illustration

Before his illness, Ted Greensfelder was a solo practitioner of law in Washington, D.C., specializing in litigation of professional liability cases. During his final year of life, Ted stalked the bays, beaches, estuaries, marshes, ponds and cypress swamps of Florida with a 35 mm camera and telephoto lens. He came upon this clamorous congregation of white pelicans at Pelican Bay berm, north of Naples. "Unlike the more common brown pelicans that dive for their meal," Ted wrote for a gallery brochure, "the white pelican joins a communal circle beating the water with their wings as they head towards the mainland, pushing the fish before them." His legacy includes images of herons, roseate spoonbills, ospreys, wood storks and many other native birds.

Bob Young
Los Osos, California
Artist & illustrator, parent, appreciator of the people In my life

Thanks, Marcus. You too, Isaac.

At midnight on December 31, 2000 or 2001 (take your pick) you won't find me in Times Square or on the Concorde. I'll be out in the backyard. I'll brush away the leaves and sit right in the middle of our grove of Pygmy Oaks. Sally and our children and a few good friends and our comical Bouvier dogs are welcome to join me. The ecology of our central California garden tells me all I need to know: there's a place on this planet for every kind of human—and for every kind of plant, spore, insect, nutrient, humus, air, finny or furry or flying animal. Not only a place, a "niche," but a tremendously correct reason for existing!

I forget which L.A. freeway I was driving when I heard the piano chords of a blues being played by Marcus Roberts. What I can't forget is the catch in the throat: "my" elation! It wasn't exactly mine. It belongs to an African-descended people and surfaced, that morning, in the rising, rumbling chords of "Mysterioso" on the "Four Giants" album by Marcus Roberts, a genius who has lightened my life… *Thanks, Marcus.*

Wondering why jazz music sometimes makes me weep (for joy) may seem a waste of time. But because this letter will be found in a washed-up bottle by a beach-comber—you—soon after the millennial turn, it's important that I try.

No less important is our friend Isaac's ability to make sense of numbers. This pale, thin, nervous, witty and nimble-minded accountant is a landsman of Frederic Chopin, born and educated in Poland. His mind reflects a pure, distilled northern European clarity and logic, but "Ike" also gets me laughing without fail as we transact our annual business of Form 1040… *Thanks, Isaac.*

Come to think of it, I need a whole lot of people—literally, a "complete set." Southern-latitudinous and impulsive and imaginative and spontaneous and right-brained-intuitive and (okay, why not?) rhythmical. Sweaty, maybe, like me. Quick to like, to love, to anger. But what a pickle we'd all be in if it weren't for the Northern, dry, cerebral, ana-lytical, left-brained, mathematical, cool, problem-solving temperaments among us! Those brainy, can-do types who analyze, compare, compute and maximize.

As the only century I've sampled winds down, I'm worrying perhaps too much about the brutish, mean-spirited behavior of a whole lot of my fellow Americans. If I may utter one final millennial scream, it is this: Knock it off! Stop the bashing, the trashing, the bad-mouthing! Pick up your toys and leave my sandbox right now! Start respecting… valuing… giving thanks for the differences that enable our human ecology to seep into all of the cracks. As Mike's painting points out, it's the Creator's master plan!

Shape up, new century! Get real, humans! Tend to basics. Educate children. Build

story

Bob—that's also I—woke up early one morning in 1995 with the germ of this essay in his/my head. "What about asking my friends to write their own thoughts, stuff them in an imaginary bottle to be floated into the next Millennium?" I asked myself. You are holding the result of that stray, daft thought. Well past my midpoint I trained to be an illustrator at Art Center. (Notice, if you please, how many of the illustrations in this book are by people who have trained or taught at this remarkable California art and design school.)

more and better libraries. Renovate tired parks. Believe that our forebears knew what the hell they were doing. Shame those tear-down guys. Aspire. Perspire. Laugh. Play Marcus Roberts and Bix and Coltrane. But do not neglect to play some Mozart and Aaron Copeland and Chopin too.

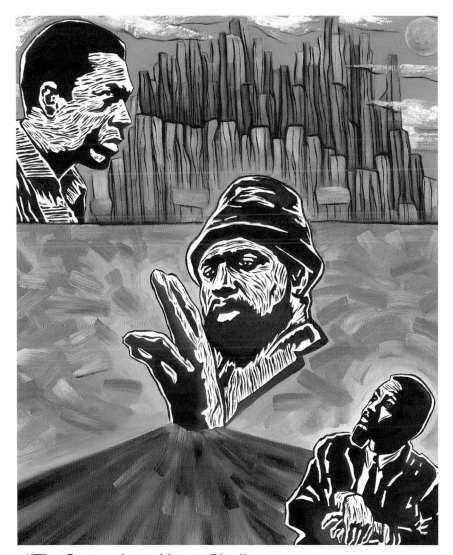

"The Creator has a Master Plan"

Michael Cano disrupted my middleaged Art Center life—for which I am *muy* grateful. Mike has shown me a thing or two about productivity (he paints like a man possessed), about color (he just nails it!), about resilience (he defies odds), and about friendship (if we weren't laughing with Mike we'd be crying). Growing up in Eastside L.A. was not always easy: titles of his prolific body of poems hint at this. He writes beautifully, he thinks clearly, he devours art history, and he will make a truly outstanding college art instructor one day soon. Trust me! Top to bottom, Mike's favorite jazzmen in his painting are John Coltrane, Thelonius Monk and Eric Dolphy. The title is after a piece by Pharoah Sanders.

John Dreyfuss
Santa Monica, California
Father of four, journalist, medical school publicist

Ouch.

It's morning.
Hot sun awakens me.
No. I want more sleep.
I roll over. Hide my eyes beneath my arm.
I was up late.
Drank too much.
Enjoyed myself. Then.
My head hurts.
A baby cries next door.
Loud radio. Awful music. Any music.
I'm sweating.
I think, "Let me sleep."
Hopeless.
The 7:40 ship to New York roars overhead.
The rocket feels as if it's *in* my head.
Neighbors eat eggs while their baby squalls.
I hear them. Smell their food.
I'll never drink again.
No more parties.
OK, up we get. Ouch.
Stagger to the kitchen.
Every step jolts my brain.
A glass of water. Another.
That's better. A little.
Sit.
Try to read, hear, smell the news off my screen.
Not yet.
Close my eyes.
Rest.
Coffee now. That helps.
The sun's tolerable.
Cool shower.
I sit, feet up.
Half an hour. An hour. Better.
I dress.
Walk to the pneumostation.
Ride to Starbucks… in welcome silence.

John and I were classmates at Polytechnic School in Pasadena. He wrote for the Los Angeles Times *for years about architecture, education and anything & everything. Readers were often rewarded with his wonderful humor. For a few years I was an education writer, so we were colleagues and later neighbors. Now John is Associate Director of UCLA's Jonsson Cancer Center. He and his wife, Kit, both row single-sculls and win Master's races. They have four extraordinary children and two spectacular grandchildren.*

story

More coffee. Vita-bun.
Home again. Headache's gone.
I'm smiling.
My grandfather's grandfather wrote that
 he had mornings like this "in my day."
His day was near the turn of the century. When he was my age.
Well, it's near the turn of the century again.
"No matter where you go, there you are."

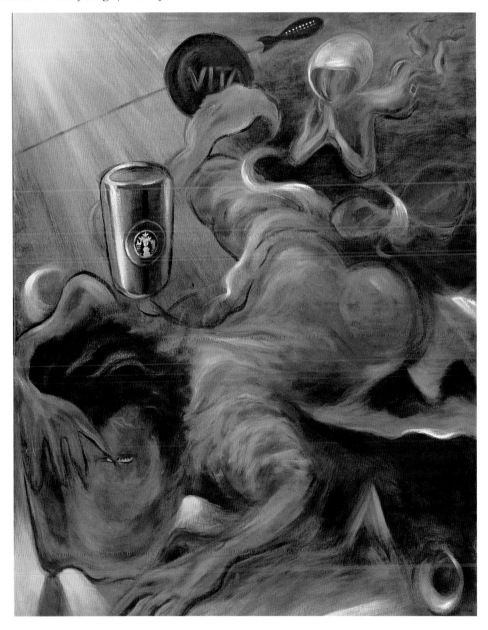

The illustration is mine. The art part of me grew out of nonstop doodling as a boy, and if any publishers are out there, I have a manuscript and trial illustrations for a children's book, "The Doodler." In 1992 I graduated from Art Center in Pasadena, just a few blocks from where I did my boyhood doodling. Along the way: reporter & writer for *Newsweek* and the *Los Angeles Times*. My two children, Bud and Jody, are going great guns. Their mother, Gretchen, died in 1988. I am now married to a lovely librarian and graduate studies teacher named Sally. We live on California's central coast with Gus and Molly, the big fuzzy Bouviers named in Ken McKnight's essay, "Got bones?"

Don Wolfe
Little Rock, Arkansas
Devoted parent, brave soldier, gifted painter, excellent friend

Tolerance

Wedged tightly between two burly MP's, Sergeant Baker slouched and avoided my eyes. Blood dripped from his nose and a jagged gash above one eye. "He's all yours, Cap'n," said one MP as he left my tent. "Good luck!"

Damn. Once again, Sergeant Baker was shit-faced drunk. Once again, he had provoked a fight in the village. Once again, I'd take away his sergeant's stripes—only to give them back within a month.

Baker was drafted following his college graduation in 1966, and became part of the Vietnam buildup in 1967. Raised in a transitional suburb of a major Midwestern city, he had gained street savvy and fighting skills. He became a valued "grunt" as our platoon patrolled the bush. Sadly, when we periodically returned to the battalion base camp to mend our bodies and spirits, Baker installed himself in anger and drinking. His head fuzzed with booze, he would goad a target until a fight ensued. He took pleasure in lashing out at the "niggers," the "kikes," the "wetbacks," and the "gooks."

Of this man's courage there was no doubt; he'd proven his bravery in combat frequently. We *all* suffered the annoying *inconvenience* of this war—but only Baker desired to personally extend the war's brutality within our unit. The behavior was as puzzling as it was repulsive. In the field, we all depended upon one another for survival—concerns about race, religion, politics or gender were non-issues!

As the Millennium of Sergeant Baker's and my war draws to a close,* I find my past colliding with the present. I was raised with the notion that Americans strongly hold a sense of fair play, and yet it now seems commonplace to hear accusing and vociferous voices, like Sergeant Baker's, bashing and smashing other human beings because they dress, look or act differently than we do. Snide remarks bandied *sotto voce* aimed toward gays echo in the halls of our nation's Capitol, and crude swastikas appear overnight on synagogue walls. Southern black churches are torched and destroyed. An abortion clinic is bombed—people are killed. There are reported incidents of job discrimination based upon age, gender, race, religion, sexual preference, etc. etc. etc. What happened to the American dream of equality for all? And how about that haunting advertising message on TV, "Be—all that you can be!"

I suppose there is blame for all of us. Everybody grew up with somebody like him (or her), the archetypal teacher's pet and class tattletale, so infatuated with his own righteousness he's flabbergasted when others don't embrace his exaggerated opinion of himself—the pious, holier-than-thou type. Perhaps we have simply become inured or submissive to acrimonious finger-pointing and dehumanizing vandalism. We can analyze

* For the record, Private Baker (not his real name) was discharged honorably in 1969, and today is a successful trial lawyer in a major Midwestern city. Even a blind pig finds an acorn sometimes!

What sort of irresponsible, immature, weird guy would even think of starting art school at age 50-plus ? Don Wolfe. Me, too. We two I.I.W.G.'s bonded in strong friendship soon after we met at a coffee shop near Art Center on a rainy day in 1994. He had just dropped a career as a marketing S.V.P. with a Fortune-500 firm to pursue a dream of becoming a landscape painter. Today Don Wolfe's work sells in galleries in Arkansas, Oklahoma and Texas. Don served in Vietnam with army paratroops and was twice wounded. He and his wife Becky, a medical administrator, live in Little Rock, Arkansas. They have two grown children.

story

the situation, look for the much overworked "root causes," and we can absolve our role with the thought that we did nothing to aid and abet the villains.

Yes, I do believe it's important for a free society that ordinary citizens be allowed to state their views safely, to disagree and to protest if they're so moved. But, I am sick of the fringe, loony, freaky talk with the hate literature, the intolerance and the violence. I'm sick of these bullies, from the classroom to the boardroom to the legislature, shouting down, insulting and cowing decent, reasonable people. I believe we must recover and nurture a love for statesmanship and calm discourse. Let's lower inflammatory, agitating rhetoric. Let's encourage civility in our contact with all people. Let's be tolerant of our differences—we can overcome this dysfunction of our social order. As we walk across the bridge to the 21st Century, let's look the Sergeant Bakers and all other bullies straight in the eye, and proclaim it loud & clear: our best hope is tolerance.

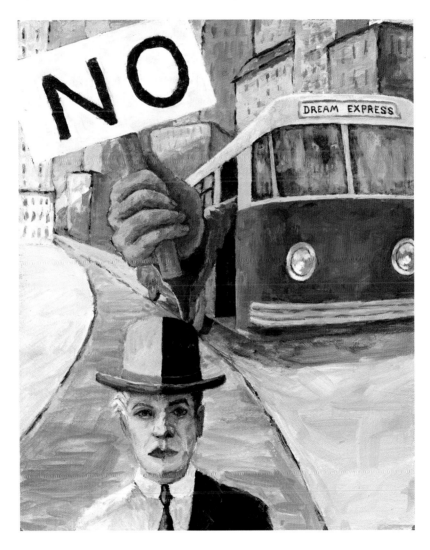

Don painted this "nightmare scene" (his words) to illustrate his own essay. His infatuation with pigment—the grab & texture & light & dark & glaze of oil paint—is what eventually led him to the full-time study of art. The image is very different from the landscapes that he loves to paint, and which are finding places in many homes in the south-central region of the United States. The feelings of being denied, of being excluded, of not quite belonging, of being divided—none is foreign to a former army officer and corporate bigwig who has decided to pursue a serious art career in his mid 50s.

Ken McKnight

Los Angeles, California

Photographer, high school teacher, Mojo-surfer

Got bones?

Here's my advice: have a dog accompany you into the next Millennium. Dogs are important for many reasons. They understand fun, they are good workers and can save a life (maybe yours).

Best of all is their *spirit of dogginess*—which is the ability to lose themselves totally in whatever provokes their interest and have a great time doing it. Consider Molly and Gus, great gallumphing Bouviers in Los Osos, California. They have mastered the art of having fun. During a typical morning, they will chase squirrels, uproot some garden flowers, run after a ball, drink water from the toilet, dribble water on the hardwood floors, eat breakfast, flop down and pass gas, take a long nap, wake up and chew on each other.

Dogs don't worry much. They could care less if the Dow has an "up tick" or whether Ken Starr's "Sky-Is-Falling" hysteria make the six o'clock news. Also, they have the good sense not to work in offices, preferring the great outdoors. There is a lot to be said for doing stuff like chasing cats, burying bones and digging up flower gardens. These activities promote improved cardiovascular efficiency, teach saving and thrift and help prepare the soil for spring planting.

Dogs can be exceptional workers. Gus and Molly's Flemish ancestors herded sheep and hauled milk wagons and mine carts in Holland. They are, quite frankly, underemployed today, but could easily haul Amtrak trains or serve as wreckers hauling semi trucks.

Working dogs often have unusual job skills. Beauregard, a Lhasa apso from Atlanta, is very good at chasing flashlight beams in the dark and is a fabulous Frisby fetcher. Pooh, also of Atlanta, was renowned for bouncing ballons during birthday parties. Cookie, a cocker spaniel from Los Angeles, went everywhere with a ball in her mouth and could find tennis balls in the thickest of ivy. And Guenevere, a Los Angeles basset hound, would go to the beach and find dead pelicans with unerring accuracy.

Dogs can be very heroic. When I was one-year-old, I began crawling down a bank toward a river. Bobo, our cocker spaniel, grabbed me by the diaper and growled, alerting my mother to the situation. I could easily have drowned without Bobo's quick thinking.

When I was ten, Silver—a magnificent German shepherd—saved my life when I became lost on Hay Stack Mountain in northern Maine. I had assured my sister and her two friends that I knew the way, but coming down the mountain I made a wrong turn. It was starting to get dark and cold. But Silver knew the trail and we followed him quickly down to the base, where my anxious grandmother was waiting.

On my death bed, I don't want to say "I wish I had spent more time at the office." No, Sir! I want to say: "I lived like a dog!"

story

Ken blazed into my life wearing his trademark loud, taste-defying Carib shirt soon after I moved to Pasadena. The Thing-About-Ken was his endless supply of awful jokes and mordant, funny, original observations about everything & everybody—especially some of the more strident fin-de-siè-cle fools inside the D.C. Beltway. One can see why high school students (and Bouviers) relate to this guy's irreverent wit. Ken's superb photographs of Tobago and Trinidad may soon find a publisher. Loves to surf monster waves, hike & go camping, and shag a well-chewed red ball with Gus Young.

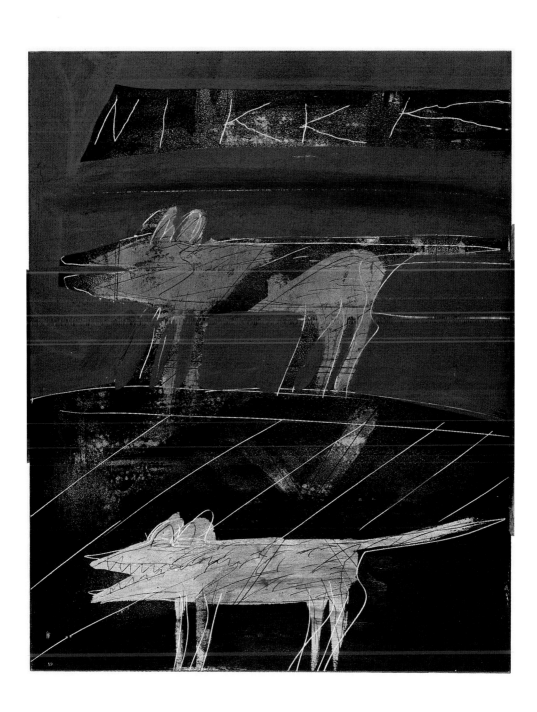

45

The illustration, one of his legendary "Enzo The Dog" scenes in acrylics, is by the late Dwight Harmon. Dwight , a significant friend and my favorite teacher at Art Center, was cruelly murdered in June, 1996. (Please see the dedication page.) This book project had Dwight very typically enthused. He had just about completed this "doggy" painting when he was taken from us. Well over $75,000 was raised for a memorial scholarship fund established by hundreds of Dwight's sad, angry, dedicated former students and friends at Art Center—with significant help from Hallmark Cards.

Dick White
Palm Springs, California
Creative advertising man, quiet wit, gentle *connector*

Seeyaround.

I find myself in a deep quandary—a 300 word-deep quandary—of needing to deliver, with some sense of urgency, a message that will convey my whimsy, my foreboding, my serious concern and, perhaps, some advice for the future: the coming decades and the folk who will be around then.

Obviously some degree of arrogance has to be called forth and that, for me, is not easy being the laid-back, taciturn invididual I am. That stated, my word to those in the distant future is to keep connected. Connected? Right! *Connected!* That means to stay in touch with one another.

As "my" Millennium draws to a close we don't do so much of that. We isolate ourselves from one another. We are masters at it. Our days go something like this: we awaken with the remote-controlled giant screen TV imaging the world's news repeated ad nauseum by golden-voiced, too-beautiful faces—we access our computer monitor and keyboard to the Internet and kick in the chat line, where, using some quirky name, we write a few conversational questions and answers with some unknown and unseen someone, also with a quirky *nom d'electron.*

A simple click and all that disappears without so much as a fond good-bye and we are on to another encounter from some other information source. Our CD/ROM is spitting out the latest visual images to match our audio voice tracks. Meanwhile our voicemail equipment is screening our incoming messages and our remote control is automatically setting the VHS to record our favorite sit-com for a moment when we will have time to view it. We click the magic mouse to check our e-mail messages from the new and intimate friends we've made on the chat line. The chat line has become our lifeline to the world at large and using a safe moniker, not our real name for heaven's sake, we engage in pseudo-serious and shallow question and answer sessions with unknown and quirky-named individuals. Disinterested (or bored) we simply click off without so much as a polite "solong" or "seeyaround."

We head for the office, car doors automatically locked, windows rolled up, controlled temperature quietly functioning and our CD player filling the interior with lush sounds to drown out the traffic roar around us. The drive-through eating facility affords a minimum of words and contact and we are off to the rest of our isolated life. Our cocoon—a technical masterpiece!—is almost complete.

That ain't connection! We have spent the entire day (days) without having looked into one human eye, touched one warm human hand or even hugged another person in a friendly gesture. *No connection!...*

Dick was about to rework the ending of this essay when he became ill and died, in July, 1988. He was an intensely warm, magnetic, articulate, and spiritual person. We had met in a men's breakfast group at our church, All Saints Episcopal in Pasadena. His twinkling humor and positive outlook made a fine impression. An advertising and public relations exec for many years, Dick was enthused about marketing satellite dishes for homes the last time we talked. I miss him very much. A beautiful human being.

story

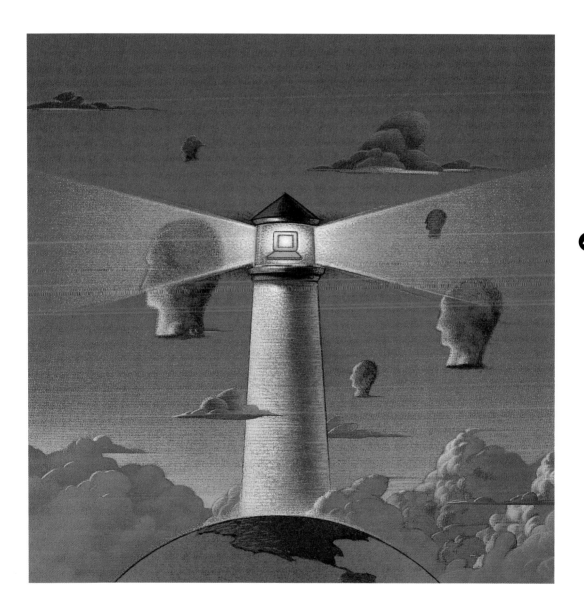

David Tillinghast operates an art factory! Well, it's a whole lot less "industrial" than it sounds. His images—hundreds of them—are used again and again as iconographic symbols for issues and themes found in such publications as *Business Week*, the *Harvard Business Review*, *Fortune* and *Los Angeles Times*. I was fortunate to know David as my down-the-hall office neighbor: dependable, kind, thoughtful, and gently humorous. One amazing artist, in my opinion! His images are thought-provoking and beautifully composed. David is a graduate of Art Center, where he has also taught advanced advertising illustration.

Miriam Covington
Los Angeles, California
Wise elder, comforter, adventurer

Keeping lubed and oiled!

Making things better is everybody's responsibility. Stop blaming the government, businesses, organizations, religion, families, individuals. Responsibility is spread all the way across society. The good news is that there are things each of us can do right now to make a difference.

A lot of things look bad at the end of "my" century. There are awesome problems and challenges—so many, I can't think of them all at once as they are inclined to overwhelm me. But, yes, I worry about… the human threat to Earth's environment… the hole in the Ozone… the complexity of the information glut… the shortcomings that appear in human nature… violence as a way to settle differences… the unequal distribution of human rights… and the scarcity of honor and decency all about us.

What can I do with any of this?

I send small checks to many causes. It is sort of like voting for the healing of the environment or of human nature.

Part of me wants to curse the century (old or new, doesn't matter) and humankind. The awesome level of waste and conflict and the adversarial treatment of issues pits us against the government, us against drugs, us against violence, us against destruction of the social fabric. It's me against guns, crazy drivers, people who overcharge, overreach and push to get ahead in line.

The risk to me as an individual is discouragement, despair, withdrawal. I wonder: Is my lifetime of effort making any difference toward peaceful resolution of conflict, toward clear-eyed respect for others and for our earthly setting?

The message I formulate is this: We each walk through this world a year at a time, a day at a time, an incident at a time. So check: Is the trail behind me messed up or cleaner for my passing through?

Do I leave it trashed or improved? When I speak, is it kind, is it necessary? The economy has caused lots of cutbacks, so now the restrooms in my office often go dirty, papers on the floor, sinks soapy—a repulsive mess. I stand there grouchy and pondering: Do I need to be tended? Do I deserve a lot of services? Who messes this up without thinking of what their towels on the floor do to the bathroom environment or to the fellow workers who come later?

I decide it is my job to leave it better because I was there. I pick up the papers, stomp down the wastepaper basket so it will hold more, wipe the sink with a towel and report the stopped-up toilet. Wow, it didn't take long! No big deal. No one needs to know, just me. Things are better because I, Miriam, walked through. So it doesn't have to be big… seen… or given credit. My walk leaves:

- Someone laughing
- Someone heard

At a low point in my life in the late '80s, Miriam got me moving and lifted my spirits in our 6:30 a.m. aerobics group at the Westside YMCA. Her many years of work as a school counselor and psychologist with the Los Angeles City Schools she describes as "attempting education for the unwilling, impeded, or blocked." Miriam's parents, both physicians and Quakers, instilled deep concerns for equality, simplicity and peace. These concerns were furthered by work with the poor in rural Mexico while a student at Antioch Collge. Her four children grown, Miriam lives in Westwood, California.

- Someone taking heed
- Someplace cleaner
- Some person more functional
- Some serendipitous good deed suggesting to others: Pass it on!
- A kindness to generate kindness in others

Gain the comfort of knowing that I am a part of the wonderful whole, a cog in a wondrous machinery. I will keep myself lubed and oiled for the tasks assigned by my being there, wherever I turn up through the years. I am there for a reason and things are better because I am there.

I don't demean myself because my tasks are not monumental. I am not here for public acclaim. I am a relevant cell in a body, a responsible part of a system that works well when the parts work together. It's up to me to make the first move, to be spontaneous, generous, open and light-hearted and kind.

49

illustration

In high school Cara Martin impressed me with her photographs. In college, it was her watercolor paintings. Her main art thing, and her thriving occupation since graduating from Loyola Marymount U. in Los Angeles, is creating sophisticated designs on computers for up-scale clients—developers, mostly. She works for a small creative firm in Palos Verdes Estates. She has also done work for nonprofits like Los Angeles' Natural History Museum. Cara is my wife Sally's daughter. She is lovely. Smart. Terrifically talented. And fun to have around.

Brad Williams
Pasadena, California
Historian, avid outdoorsman, humorist, friend

Bangs: Big, Little & Medium

Dear post-millennial reader: I'm sorry for your sake, although it can't be helped, not now. You were born too late, too late to experience firsthand these premillennial good times, a.k.a. "good old days." Let me fill you in on what you missed.

Bang! That's what. Bang. Bang. Bang.

As a historian, I want to wax nostalgic. You probably don't know what that means since "waxing nostalgic" passed out of the language about when Ron and Nancy Reagan headed back to Brentwood. I don't even know what it means for certain, but you can think of it as similar to waxing fruit, if you still have fruit and not gelatinous fruit-like flavenoids. But I digress…

The 20th Century opened with a bang. Literally. The Japanese fought somebody called the Russos in a war that was stopped by a meddling U.S. president who carried a Big Stick. He received the Nobel Peace Prize, an award created by another Big Bang (Alfred Nobel invented dynamite), for inventing a huggable plush toy bear, thus becoming known as "Teddy" Roosevelt. Political marketing and the photo-op were born that very day.

That piddling little war was cap pistol stuff compared to the "War That Should Have Ended All Wars." The "Great War" was as noisy as it was great, especially for the lucky fellows on both sides who spent years in the trenches hurling bombs and insults across 100 yards of once-prime European real estate.

Oh, yes, the Millennium that created Brad Williams also created real estate agents, who you now find indispensible. Imagine how hard life was before their invention. They "simplified" direct hand-shake negotiations between two people by insisting on inspections, competing bids, title searches, closing costs and the time-saving escrow procedure. For this they receive a laughably small percentage of the selling price from both parties, thus ensuring no conflict of interest. Perhaps you have taken this concept further. Just remember which 1,000 Year-Time-Span invented it, Sir or Madame!

Before getting to mid-century, we decided to have another war. This was known as the "War That Could Have Ended Everything." The people who fought previously in the trenches couldn't get enough of a good thing, so they did it again. Progress was a hallmark of the 20th Century. We couldn't do anything twice without improving it. One company even told everyone "Progress is our most important product." They weren't kidding. By the century's end, they had progressed to owning practically all the United States, except the Congress, which of course can't be bought, although this may have changed by the time you read this. Anyway, the "Good War" was so good that the combatants decided to let civilians in on it, whole races of them. The fun ended with another Big Bang.

Brad and his wife Susan are cherished friends. Susan heads the reference desk in the Pasadena Public Library. Brad directs the historical society for the federal courts in the Western United States and edits a firecracker of a journal. I came to know Brad as "kid brother" to my great friend Stan who died in 1984. Often, Brad and I would go along as ballast on Stan's fast PC racing sailboat. He leaves me huffing in the dust/snow as a gung-ho hiker and avid cross-country skiier.

Lest you think everything my Millennium did was all skittles and beer ("skittles" was another name for "baseball"), we really messed up with atomic energy. It really wasn't good to use it just in bombs. I hope you have learned from our mistake and are now using it where it can do the most good, namely to power airplanes and bake bread and floss teeth.

My own cohort became bored with the term "war" and started calling them "conflicts," but that didn't diminish their popularity. There was one in Korea and another in Vietnam, but neither was very significant or had a lasting impact on the participants. (Except for the ones who died.) I only mention these scuffles and tussles in case you wondered what they were. Forget about it. (This was a popular late 20th Century expression, meaning "Don't bother me with trivia; I'm watching football on television.")

My summary of the good old days wouldn't be complete without mentioning our proudest bequest to the 21st Century. I'm speaking, of course, of that yummy articicial orange-flavored beverage, which in our times was consumed by the bucketful. Served chilled, it's named for the 20th Century's most popular activity. That's right: Orange Bang!

When you drink it, remember to toast the Good Old Days.

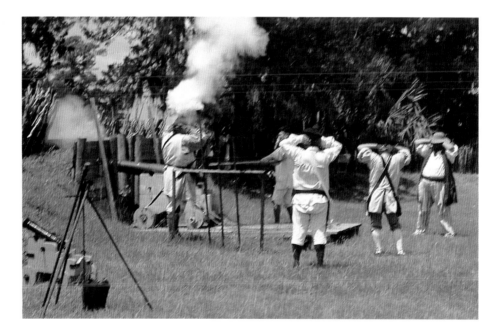

One of the last of the true 20th Century gents is our new friend Henry Childs, a Connecticut Yankee transplanted to the central California coast. A fine photographer, Henry has published two gorgeous books, *Gardens & Graveyards of the Southeastern Seaboard*, and *Litchfield County*—the latter an exploration of the northwest corner of Connecticut. Soccer standout at Yale, Japan scholar, former schoolteacher, wine conoisseur: quite a guy! His eyes are wide open, always looking for that next shot, whether at a 4th of July parade or in a high mountain pass in Idaho. Henry shot the "Bangs!" picture during an historical reenactment at a 1712 British outpost on the Georgia coast.

Michael Sizer
Sierra Madre, California
Caring husband, dad & grandfather, master electrician, infectious laugher

My message to Millennium III

Keep in the forefront of your mind that we are human and that personal interaction between us is of the most importance.

As civilization becomes increasingly sophisticated and our means of interaction becomes more and more impersonal we lose the person-to-person, face-to-face, eye-to-eye, heart-to-heart communication. No matter what our circumstance or position in life, we are all equals with the same inner core. The real values in life are found in personal friendships—in being of service—in giving. Taking the time to invest in someone's life is investing in our own. As one grows older and looks back over the highlights of their life, what stick out are those times in which someone has taken the time to help another.

Giving gives back. Even the simplest gift, that of a smile, radiates out touching others in one way or the other. Positive acts beget others. Kindness is appreciated. You know how you feel when someone is nice to you. Return that to another. You never know when or where the seeds you sow will spring forth. The world is what we make it. Our investments in other humans will pay off, either directly or indirectly. If you want to give something that will be remembered to society, invest patience and love in children. Keep a sense of humor. God bless. Love.

52

Mike was our electrician when we lived in Altadena. He is a masterful faulty wiring detective and problem solver. Big, bearded, capable, friendly, twinkly-eyed sort of hippie guy—so highly esteemed for helping folks that his home town of Sierra Madre feted Mike as "Man of the Year" in '95. "Survived cancer. Enjoying life more. Active at church, community as usual. Into walking dogs, spirituality. Happily married! God Bless." That pretty much, in his own words, sums up this very complete human being.

"Chameleon." Multimedia on paper, 1991. Collection of Ken and Barbara Holland

More than a teacher, assuredly a mentor, possibly a spirit guide: Franklyn Liegel helped me find joy and confidence in his night classes at Otis College of Art in L.A. His friendship and concern explain why, repeatedly, Franklyn was voted Teacher of the Year by Otis' full-time students. His "lush, teeming collage paintings" as described by a critic, are shown and collected from Japan to Hawaii to Amsterdam to Morocco. "Built up and out with layers of thread, scrim, confetti, precut strips of paint and paper that have been scrubbed, mulched, flecked, and mottled beyond recognition... they suggest sculptural depth with as much playful invention per square inch as is possible."

William "Bud" Young
New York City
Airline passenger service ace, linguist, travel afficionado

Eagerly awaiting...

I can't help but be amused by the way American pop culture has been straining to "revive" past decades. In one single late 20th Century day, it is entirely possible to:

- watch endless reruns of "Leave it to Beaver," "Happy Days," and the "Andy Griffith Show," which remind us all of how pure and innocent we were supposed to have been in the 50s;

- observe neo-hippies, reeking of patchouli, zooming off to their next Woodstock revival or Allman Brother show in their lovingly preserved, 60s-vintage VW microbus (that now features a $3,000 sound system and cell phone);

- boogie down with the Village People, revisit Studio 54 and buy a $300 "novelty" Lava Lamp from the catalog in the seatback pocket on the airplane;

- and find evidence everywhere that—with the rallying stock market, newfound fascination with steaks, cigars and martinis, and $1-million-plus trophy homes crammed onto postage stamp-sized plots of land—the Reagan-Trump-Helmsley-80s haven't entirely faded away.

My dad, who graduated from an all-male Ivy League college in 1957, tells me he is amazed to see guys my age swarming around New York and L.A. in white shirts, narrow reppe ties and close-cropped hair. "This is where I came in!" is his comment.

Seriously, though, my hope for the new Millennium runs deeper than the frantic fascination we all have (yes, myself included) with symbols and icons by which we define ourselves. I hope for a day when the media will no longer bombard us with dumbed-down drivel appealing to the lowest common denominator. I look forward to reading statistics showing the number of schoolchildren who really need to be sedated on Ritalin and Prozac has diminished dramatically. I dream of waking up one day knowing that people are taking responsibility for their own problems and actions and not blaming everyone and everything else under the sun. I eagerly await the day when lawyers will have to take on second jobs because their just isn't enough anger and contentiousness to feed upon any more.

I often wonder what it would be like to be truly shocked, outraged and disgusted upon hearing on the evening news of the senseless death of another child. (As callous as this may sound, nowadays we hear this kind of thing so often that it seldom elicits more than a "hmmph" and a slow shake of the head.)

Perhaps most of all, though, I look forward to experiencing life in a world where being Democrat, Republican, Black, Latino, Jewish, WASP, left-handed, right-handed, size 2 or size XXXL, gay, straight, Type A, Type B, jock, nerd, nuclear physicist or garbage man

Known as Bud to his friends and family, but Bill to most others, my son William was bitten by the "travel bug"" (his words) as he attended school, summer camp and college in five states. I recall his accurately identifying any and every aircraft flying over our Santa Monica home or his school yard. And he quickly absorbed details about rail and bus systems and street layouts of every new city he visited—and others that he only knew from transit maps. Fluent in several languages, this talented, friendly, down-to-Earth guy is part of a team responsible for on-time departures at United Airlines. He's based at LaGuardia Airport in New York City and has a getaway place in Vermont.

(oops, sorry: sanitation facilitator) will all come in a distant second to the importance placed on being a good, decent, friendly, unselfish, contributing member of society.

Too much to ask? Maybe. I'm not holding my breath…

… but I *do* have the champagne chilling.

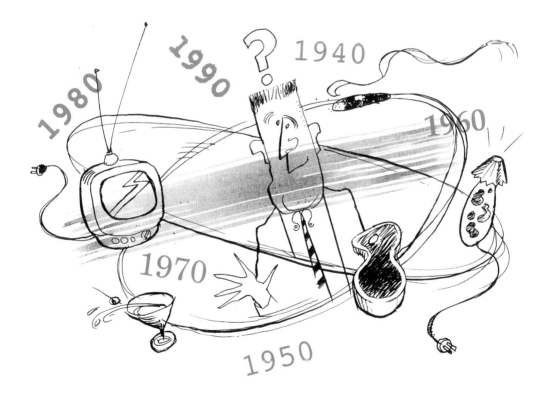

Who else but "Dad" is qualified to illustrate Bud Young's essay? Reason enough is that my silly cartoons, sketches, caricatures and "dumb drawings" have forged a bond of laughter between my son and me since he was very little. Indeed, his love of humor defined and governed his school and college years. He would put out effort for any teacher who had the gift of humor. But for the occasional sour, dry, humorless pedant, he would just lay down his pencil and refuse to learn! This, of course, led to all sorts of tragi-comic confrontations between Learner and Authority. Fortunately, though, the risible teachers outnumbered the grumps, and Bud prospered as a student & linguist.

John Trotti

Santa Barbara, California
Journalist, author, jet & motorcycle pilot, peaceful warrior

Killer Complacency

The morning after I reported in to Saufley Field, Florida, to begin flight instruction, I was greeted with a sign obscuring half my bathroom mirror employing the Gillette Safety Razor Company's tag line, "Sharpest edges ever honed." Instead of the classic blue-blade, however, the motto was accompanied by a picture of a half-headed man holding an aircraft propeller. The remainder of the mirror was taken up by a frame-like sticker allowing just enough room for me to see to shave, bearing the reminder, "This is the person responsible for your safety."

At the time in naval aviation, the odds were that a pilot would have an accident in something less than three years. That struck me as stupid because it meant the loss of a half-million dollar airplane, at least twice again as much in wasted training time and likely the forfeiture of my own ambitions. Somewhere in the recesses of my mind I figured this for a bad deal all around.

That evening I halved again the mirror's useful area by stenciling in my favorite admonition, "Complacency Kills," certain that I knew where the demons lived.

Within a decade the accident rate had sharply decreased—and I had done my part by beginning and ending every flight briefing with the reminder, "Complacency Kills" (and also by maintaining a one-to-one relationship of takeoffs and landings). By my reckoning I was easily the least complacent person on the planet.

I moved on from combat flying more than a quarter-century ago, but in recent months I've had occasion to dust off a number of skills and processes as I have prepared to crawl, once again, behind the stick of a high-performance jet fighter—a MiG 21 that I have helped to restore. When you strap into an ejection seat you forsake prudence in favor of the narrower but more-expedient "act before you think" rationale that seeks to provide a barrier between complacency and its consequence. After all, you tell yourself, the object is to stay alive, an important issue for a 25-year-old immortal whose vision of time is that of a river flowing off to an uncertain horizon. But what about for a 64-year-old to whom time is the precious item? Does it really matter that complacency kills? Maybe, but at what cost?

Having time is a passing fad. Making use of it is the issue. The lesson is not one that refutes the understanding that complacency can kill the body, but that at a much deeper level, complacency sacks the spirit.

story

This funny guy whose engineer boots and "ducktail" drew official frowns at the California boarding school we both attended—well, he turned out just fine. In the Marine Corps after graduating from Stanford, John flew Phantom and Skyhawk jets on two Vietnam tours. His book about the expeirnce, Phantom Over Vietnam, *is well written, sensitive, thoughtful, funny. Recently he helped restore a Russian MiG 21 and its maiden flight from Santa Maria to Palmdale caught the attention of awed groundlings: "This is not a sporting machine," pilot John said, "but a barely controlled dart." He rides a very fast motorcycle to work in Santa Barbara as editor of respected industry mags. Vroom. Whoosh.*

Gary Meyer's masterly gouache and acrylic paintings have won more than 84 prizes including the Founder's Award from the American Society of Aviation Artists. His realistic, action-packed portrayals of airplanes and spacecraft (including fanciful stuff for *Star Wars* and *Star Trek the Movie*) have won a big following for this genial, soft-spoken, modest artist. As a teacher at Art Center, Gary glows. He inspires loyalty and coaxes forth the best of every single student's abilities—even getting them to *like* doing perspective drawings. (I count myself lucky to have been one of them.) Gary's paintings for clients such as Boeing and Hughes Helicopters dazzle and delight with their stomach-churning vertigo—putting the viewer on top of the world!

Barnes Boffey
Essex Junction, Vermont
Psychotherapist, summer camp director, open and friendly human

A Pledge for the New Millennium

Perceiving ourselves and others as victims has become an American pastime. "It's not my fault," "I'm not responsible for my feelings or my behavior," "I can't help it—it's my past, my boss, my kids, my wife or my handicapping condition." These are the banners that fly from the parapets of post-responsible America.

In this environment of institutionalized victimhood, people are unable to find emotional and spiritual balance in their lives. With the belief that "I am not responsible" comes the concurrent assumption that I am controlled by the forces around me. From there it is a short leap to believing that "If I want to feel better, I must change the forces around me that make me feel angry, depressed and unsuccessful or I will continue to feel and act as I do."

Healthy lives and fulfilling relationships are created by people who understand that they create their emotions, attitudes and behaviors in any situation. The situation does not cause anything. The situation provides information; the individual chooses what he or she will do with that information... be angry, be grateful or be indifferent. Obviously, certain "pieces of information" are harder to work with than others, but we are responsible for how we act relative to that information. If three people hear the President's speech, one may be angry, one may be optimistic and one may be indifferent. It is not the speech that causes them to feel that way. The speech is just words. It is our expectations and perceptions which determine our feelings and we are the only ones who control our expectations and perceptions.

Certainly we need to create expectations to live in the real world, but when we cannot imagine ourselves being in balance unless these expectations become reality, then we are doomed to a life of frustration and manipulation. We must attempt to make everyone and everything turn out as we need them to. Since we believe we are victims, feeling and acting as we do because of what people around us do, we need the world to change before we can be responsible. We become a nation of people with Behavioral TV Remote Control Units, clicking at each other to try to get everyone else on the "right" channel. You click me, I click you... we believe we can't be happy without seeing what we need to see.

All this clicking keeps us locked in a cycle of manipulation with ourselves and others. We participate in manipulative relationships, thinking mostly about "how" we can get others to do and be what we need them to do and be. We don't consider stopping the manipulation—we simply spend time creating different styles of manipulation. We may move away from "hard" manipulation (physical coercion, punishment, anger) toward

Barnes inspired a 10th grader (my son, Bud) to change his life for the better. Respected as a therapist and also a summer camp director, Barnes helped Bud find his own firm footing in boarding school. How? By inviting Bud on Saturdays to chop some wood, ride around in his truck, and talk about... all kinds of stuff. (The two laughed a lot, too.) The growth was dramatic. Barnes has also inspired Bud as head of Camp Lanakila on Vermont's Lake Morey. His towering, friendly, humorous presence continues to help Lanakila's campers and counselors discover their "finest, truest selves."

"soft" manipulation (rewards, being nice and guilt), but the basic goal is still the same: "Change others so we can feel at peace."

Our mental health in this next 1,000 years will depend on our willingness to take responsibility for our own happiness. So I will be glad if you will accept my small offering in the form of this pledge:

> *I control and create the emotions I have because of the manner in which I am dealing with my present reality. I am not a victim of that reality. As that reality changes, I may find it easier or more difficult to maintain my emotional balance, but I am still responsible for my attitude and actions. Regardless of the behavior of others, I have the capacity to grow in my ability to remain loving, powerful, playful and free. I participate in genuine relationships because I allow others to be themselves; they do not always have to conform to my picture of who they need to be.*

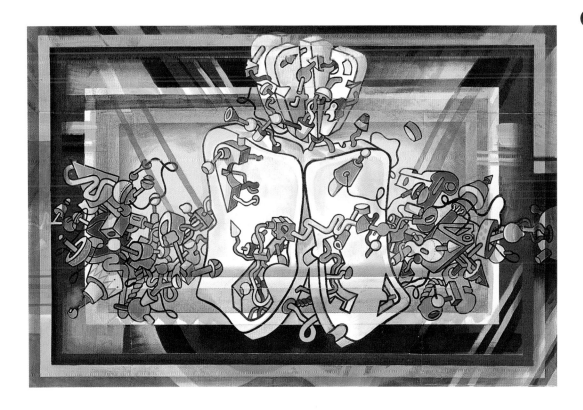

Ed Beckett is astoundingly productive. The energy he brings to his work as an artist and advertising "Creative" is a source of awe and admiration to his many friends. Trained at Brooklyn's Pratt Institute, Edward's "time worm" paintings in acrylic and oil are complex, rich, many-layered and powerful. His ceramic pieces are lovely. His woodcut prints and monotypes are crafted with terrific detail and vibrant colors. He cooks like—well, almost as well as his culinary hero, Emeril Lagasse of New Orleans. He sings like—well… like the operatic tenor he has trained with. His Hawaiian shirts are splendid and his classic Norton motorcycle very sleek and fast. All this… and a great, warm, generous friend, too.

Tom Pratt
Los Angeles, California
Investment exec, super Dad, generous, warm, pungent, witty guy

Civility

For days, then months, now the year, amidst mourning mom and bathing sons, loving dad and squinting at CNN, billg., DNA, I've etched and erased hand after curious hand holding my Millennium bottle aloft. Scroll intact, lips pursed, but without an aha.

Always, I'd pale as to what of now would be portable, much less legible, enough in the glare of that morning, 365,000 some such removed?

Gossip, slogans, videos, menus, haiku, heresays, ragings, CDs, nicknames, LPs, surnames, logos, arias? All ripe yet joyless for such spatial distillation. How'd we do it? Here's how you should do it? And don't for gods' (GOD's) sake wander down that black hallway I warned you about. I think not. Advice is only good on the curbs of life. Once in traffic, it's every homily for themselves.

Thereby my first, middle and only point. Civility. It is all we govern, don't you see. Nose to window in our own ecosystems, bent double towards the finish line, all that demarcates the journey, de-picket-fences, the journey, are the broadfaced acts of civility. Absent them, no beach, no bottle, no scroll, no aha.

I'm speaking of thank you, excuse me, may I, would you; admiring, without groping; seeing without staring; chewing with your mouth closed; talking with, not at; please. The commas, semi-colons, apostrophes of our meanderings that flag our humanity, real or imagined. Those metronomes of good taste and kindness that swell a room with friendship when right, or cut a sentence to the bone, when wrong. Opening doors, pulling back chairs, carrying others' too-heavy parcels, smiling in public. Harbors, niches, *cul-de-sacs* of human contact where speed defers to "Please, you first." Petting the dog, stroking a cat, tapping the acquarium, rumpling a passing child's hair. Catching and tossing back a runaway ball. Remember?

Now done, the cork lost, noon almost night, what would you pay for that morning? Then, please, do.

Tom and I were warming hands at a beach campfire on January 1, 1995. I had just met Tom and his wife Grace (he and my brother-in-law are longtime friends). His instant enthusiasm on hearing my idea for this book was the jump-start I needed. For one who is a VP and Registered Representitive with an investment management firm, Tom writes with uncommon skill—for which his schools, Deerfield Academy and Duke University, receive his glowing praise. The word "sprightly" fits this transplanted New Englander. We make each other laugh a lot.

The illustration is by Jean-Francois Podevin. His instructions—"take care not to crush the feather when you copy this"—must mark a First in art history. A Parisian neighbor, M. Cornet, furnished inspiration for the piece. Every day he would juggle bags of "baguettes" and groceries as he struggled to tip his stylish "chapeau" to friends, esp. the "Mlles" and "Mmes" he passed on the sidewalk. A graduate of the famed Académie Julian in Paris, Jean-Francois has done covers for *Time, Omni* and many leading magazines and in the '80s taught the senior illustration studio at Otis College of Art in Los Angeles. He and his wife Barbara live in Whittier, California.

In the year 1,000, this richly illuminated portrait of Saint Luke was painted in a German Gospel book.

Contrast this with Maria Rendon Harmon's three-dimensional art, created in 1998 (see page 27).

Both are "spiritual" images. What will a Millennium III artist create in the year 2,999? (This space is reserved for that faraway—but very real—artist's answer.)

Worth carrying with us into Millennium III are whole galaxies of attitudes & insights & new & old & ancient wisdom. Surely, knowledge will continue to accelerate. Cancer may be cured. Alzheimer's may itself be forgotten! Air and water may become pure once more. What concerns me most, however, is whether what is already known—call it "the best of Millennium II"—will actually be heeded, used, applied. In every area of life—urban design… child rearing… the "mind-body connection"… psychological health—we *already know* what helps, what works, what alleviates and what delights. Equally, we know what hurts, what annoys, what destroys, what poisons, what dispirits, and what degrades. You and I know the difference. The essays and creative images in this book share "a spark of intelligence." It's our job now to keep that spark glowing!

— Bob Young

Your own 'message in a bottle'...

Would you like to communicate your own message to the coming 1,000 year span of history?. This might be an appeal. A roadmap. A "piece of advice." A point of departure. A "last gasp." A helpful or amusing anecdote.

The messages, if significant in number, may be posted on the World Wide Web by the editor. Meanwhile, your comments will be welcomed!

P.O. Box 16105
San Luis Obispo, CA 93406

mbeach@cogent.net

The artists

Charles Bloomer
Painting on page 11

Jim Lorigan
Etching on page 13

John Clapp
Painting on page 15

Frances Harvey
Painting on page 17

Anna Warde
Drawing on page 19

Shan Wells
Painting on page 21

Joel Nakamura
Painting on page 23

Annie Jones photo

Diem Kieu ("Zim") Pham
Photograph on page 25

Kathy Ross
Painting on page 29

Dwight & Maria Rendon Harmon
Images on pages 27 & 45

Krista Dixon
Painting on page 31

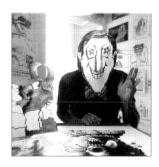

Barry Wetmore
Digital image on page 33

continued overleaf

The artists / continued

Melinda Howell
Photograph on page 35

Ted Greensfelder
Photograph on page 37

Michael Cano
Painting on page 39

Bob Young
Painting on page 41

Don Wolfe
Painting on page 43

David Tillinghast
Painting on page 47

Cara Martin
Altered photo on page 49

Henry Childs
Photograph on page 51

Franklyn Liegel
Painting on page 53

Gary Meyer
Painting on page 57

Edward Beckett
Painting on page 59

Jean-Francois Podevin
Painting on page 61